GEORGIAN BAY

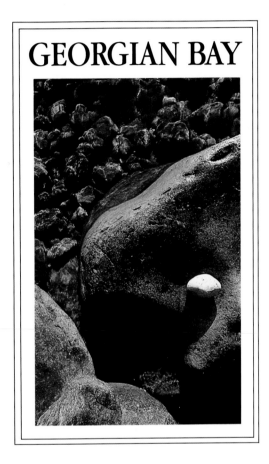

GEORGIAN BAY

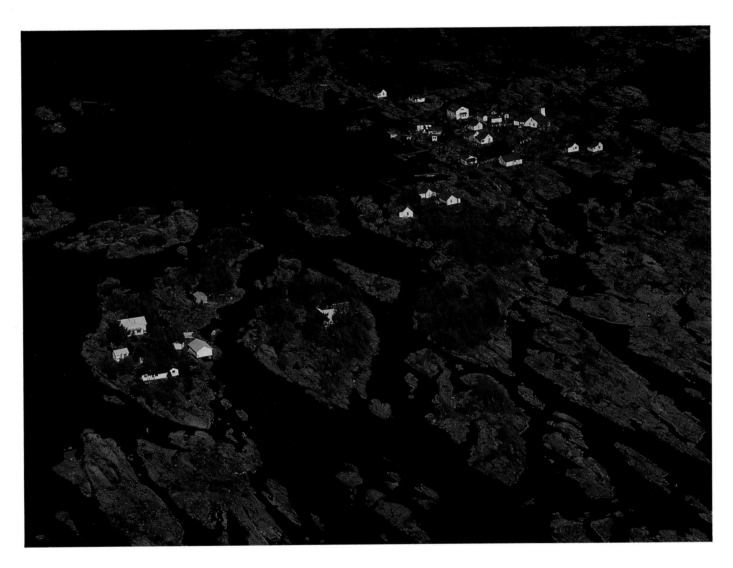

Photographs by John de Visser/Text by Judy Ross

Stoddart

A BOSTON MILLS PRESS BOOK

Canadian Cataloguing in Publication Data

De Visser, John, 1930-
 Georgian Bay

1st ed.
ISBN 1-55046-060-9

1. Georgian Bay (Ont. : Bay) – Pictorial works.
I. Ross, Judy, 1942- . II. Title.

FC3095.G3D4 1992 917.13'15 · C92-093907-4
F1059.G3D4 1992

Design by Gillian Stead
Edited by Noel Hudson
Typography by Justified Type Inc., Guelph, Ontario
Printed in Hong Kong by Book Art

First published in 1992 by
Stoddart Publishing Co. Limited
34 Lesmill Road
Toronto, Canada
M3B 2T6

The Boston Mills Press
132 Main St.
Erin, Ontario
N0B 1T0 Winners of the American Association
 Heritage Canada for State and Local History
 Communications Award Award Winner

The publisher gratefully acknowledges the support of The Canada Council,
Ontario Arts Council and Ontario Publishing Centre in the development
of writing and publishing in Canada.

Printed in Hong Kong
by Book Art Inc., Toronto

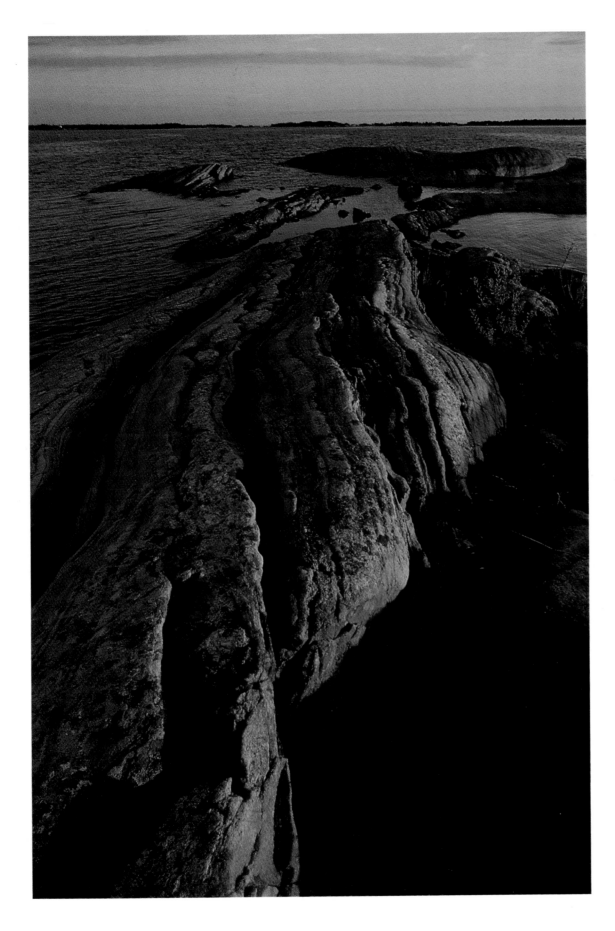

Contents

Precambrian rock in the 30,000 Islands.

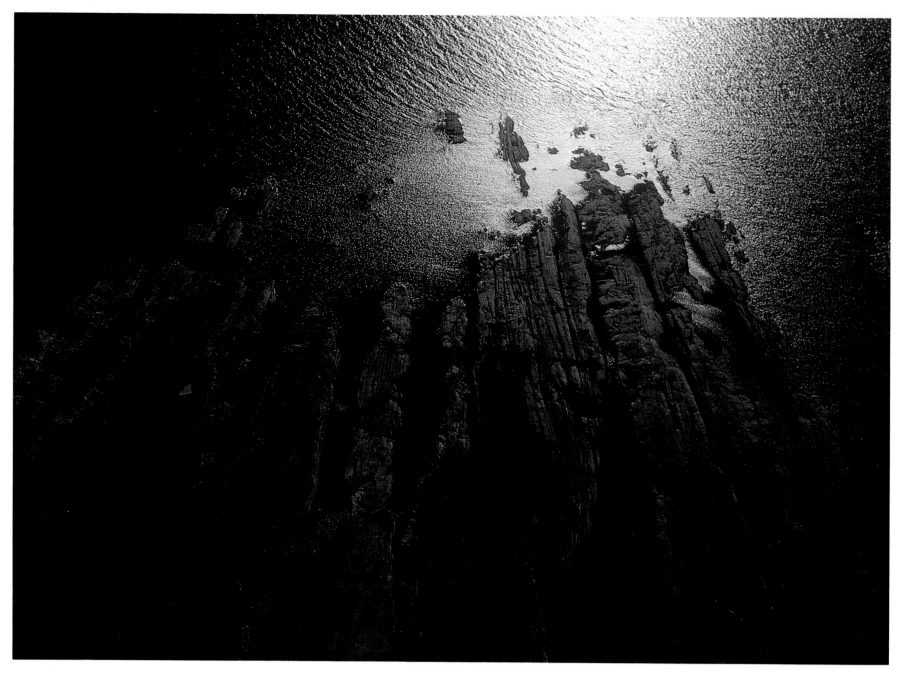

Islands combed by glaciers during the Ice Age (near Pointe au Baril).

GEORGIAN BAY — THE FRESHWATER SEA

About these harsh barren islands there is an undeniable fascination, possibly inherent in the manifest struggle recorded in their line, perhaps in the sense of remoteness and stern resistance to the encroachment of man.... A morning of serene calm may change to an afternoon of calamitous seas. It is a region of great beauty and fierce contrasts; it can be stirring or contemplative; it is always provocative.... It seems natural that this region would attract adventurous spirits.
Charles Comfort, "Georgian Bay Legacy," *Canadian Art,* 1951

These adventurous spirits began coming to the ragged shores of Georgian Bay in the early 1600s. There was Étienne Brûlé in 1610, the first white man to visit the area. He had been sent by Samuel de Champlain, the Governor of New France, to meet with and study the Huron Indians who lived on the southern shores of the Bay. Champlain himself canoed down the eastern shore in 1615 on his way to the Huron territory. Although he saw just a small portion of this vast body of water, he was fascinated by it and named it La Mer Douce, "the Freshwater Sea."

Two hundred years after Champlain's journey, Captain Henry Bayfield of the British admiralty charted the Great Lakes and gave Georgian Bay its present name, in honour of King George IV, who was, in 1820, the newly crowned King of England.

Georgian Bay is almost as large as Lake Ontario. When viewed on a map it appears large enough to be a major lake in its own right. Indeed it has been called the "sixth Great Lake," and would be if the land had formed differently and the Bruce Peninsula had extended all the way to Manitoulin Island. The length of the bay, from north to south, stretches about 200 kilometres (124 mi) and it averages about 75 kilometres (16 mi) in width. Because of the Bay's unique geographical location, there are remarkable differences in its shoreline terrain from the north near Killarney around to the tip of the Bruce Peninsula at Tobermory.

On the north and east coasts the landscape is part of the rugged Canadian Shield, Precambrian rock that swells up out of the water in clusters of low-lying islands known as the 30,000 Islands. Many of these islands are barren, smooth rock that was scraped clean by glaciers during the Ice Age. Up here the jagged shoreline is pierced by long, narrow bays and juts out in pine-covered peninsulas, a mazelike configuration that challenges boaters.

On parts of the southern shore around Nottawasaga Bay the land flattens into wide sandy beaches. One of them, Wasaga Beach, is the longest freshwater beach in the world. This fringe of golden sand gives way to fertile farmland and then to dramatic limestone cliffs, part of the Niagara Escarpment that reaches from Niagara Falls to Tobermory. Dozens of ski hills have been carved into this craggy ridge known as the Blue Mountains, and this same rocky spine continues up the Bruce Peninsula to form the west coast of Georgian Bay. Here the shoreline changes again, this time into tangles of cedar bush and steep chalky cliffs which plunge into the deep water.

After Captain Henry Bayfield charted the area, the next adventurous spirits to come were seamen, who arrived in schooners and later in steamers that traversed the Bay's treacherous waters. But little happened on land until the late 1800s, when the population grew on the south and west coasts as a result of the arrival of the lumber companies and the railroad. The railroad reached Collingwood from Toronto in 1855 and soon steamboat service became available as well,

Morning mist at Bayfield Inlet.

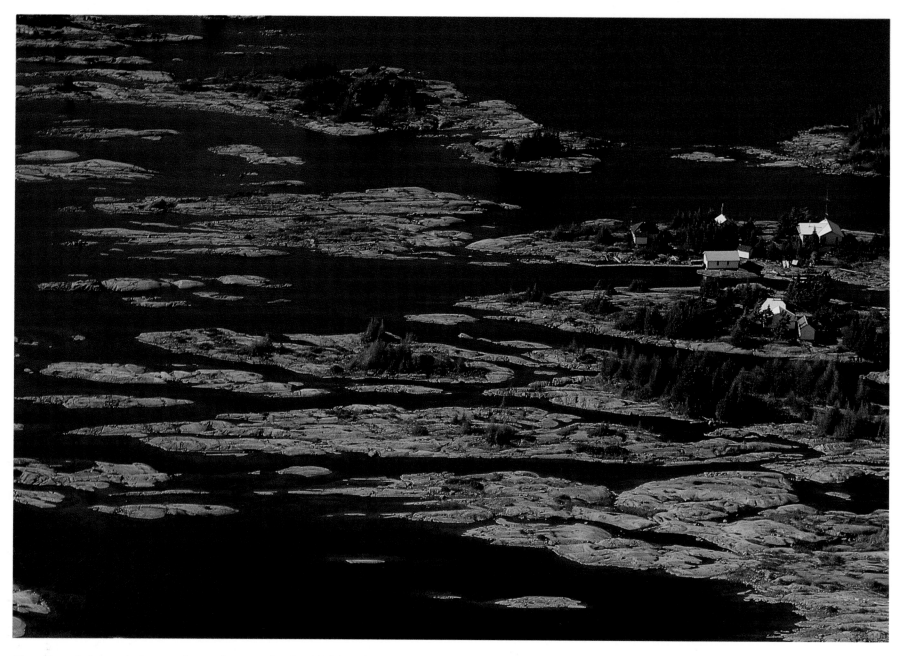

Shoals and channels form a boater's maze in the 30,000 Islands.

providing settlers and lumbermen access to land and villages all around the Bay.

The summer people began to arrive in the late 1800s. A hardy group, they staked out islands and chunks of mainland and built rough wooden structures to house their families for the two months of summer. Since that time, many summer communities have been established around the Bay, and many Bay towns now depend on tourism for their livelihood. Most of today's cottagers live on islands along the north and east coasts or on beaches in the area around Nottawasaga Bay.

Along the isolated shore of the Bruce Peninsula, a few sheltered bays embrace small communities, and at the very tip of the Bruce, around Tobermory, cottage settlements perch on rocky promontories.

Everyone who lives part-time or full-time on the shores of this vast freshwater sea possesses a keen desire to preserve and protect its uniquely wild beauty. For they know that if they keep its wilderness unspoiled and its waters pure and clean, then Georgian Bay, with all its temperamental charm, will continue to be a treasured place for adventurous spirits.

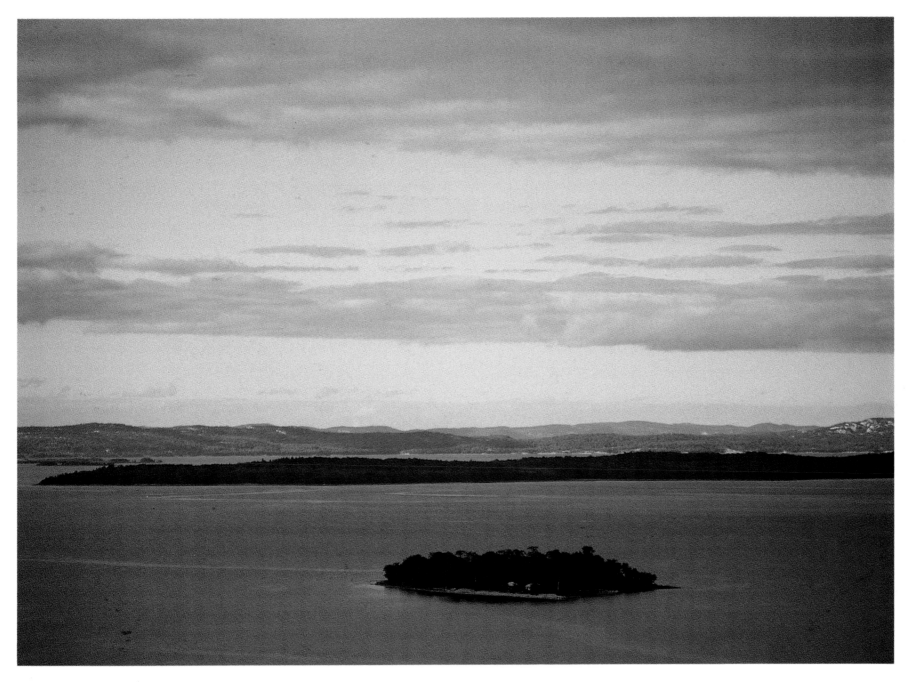

Manitoulin Island, in the northern reaches of Georgian Bay.

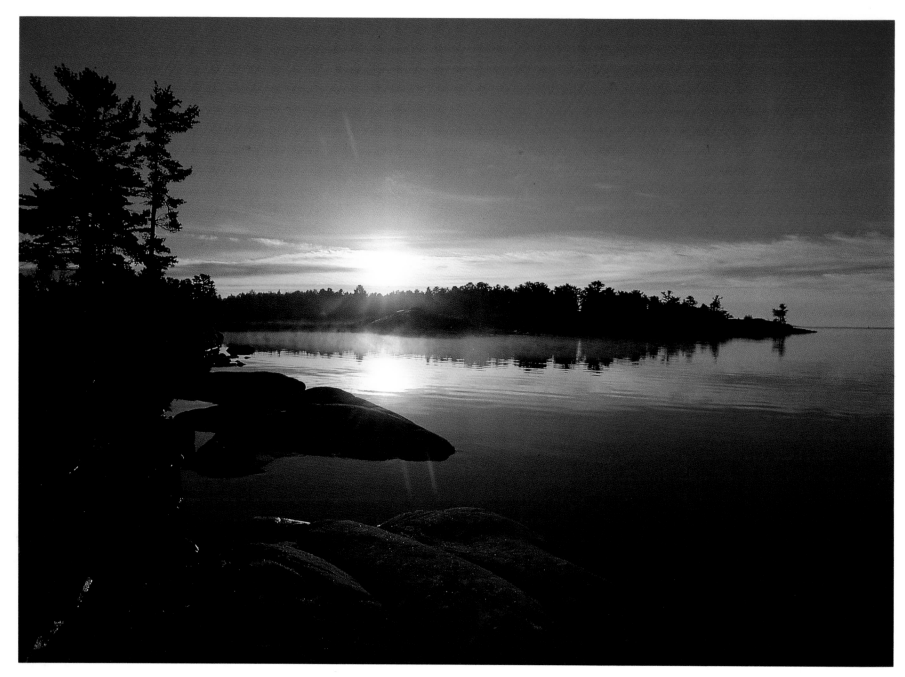

Tranquility in the Killarney wilderness.

CAMPING IN KILLARNEY

It was a summer night, the kind of night when warm breezes rustle the pine trees and the canopy of stars overhead seems just beyond reach. Three boys, escaping urban life, had come to camp in Killarney Provincial Park, the "crown jewel" of Ontario parks, at the very top of Georgian Bay. Their sleeping bags, lined up in a row, had been carefully spread across a soft bed of pine needles and moss. They lay awake, silently absorbed, inhaling the night air, fragrant with wood smoke. Beside them the glowing embers of their campfire sent ribbons of warmth into the gentle darkness. In the distance stood the unique white quartzite mountains that have made Killarney famous.

The La Cloche Mountains are so white they look as if they're covered in snow. Less than two billion years ago these rock hills were as high as today's Rocky Mountains. But during the Ice Age, glaciers scoured the peaks, grinding them down. Later, when the ice melted, an enormous lake was formed and the once towering mountains were left poking their rounded white peaks out of the water like a group of snow-incrusted islands.

Camping among these white mountains and turquoise lakes dates back to the 1700s, when the north shore of Georgian Bay was used as a water highway by fur traders from Québec. In those days the colourful French voyageurs were a familiar sight in these waters. Their job was to move trade goods by canoe from Montréal to Grand Portage at the head of Lake Superior and then return to Montréal laden with furs. These small, tough men wore bright sashes and shirts and sang exuberant songs as they paddled their large birchbark canoes. Their route took them along the Ottawa and Mattawa rivers to Lake Nipissing and then down the French River. After endless portages and rigorous paddling, they entered Georgian Bay at the mouth of the French River. There they pointed the ten-man canoes north to navigate through white-capped breakers up the rugged shoreline to Killarney.

Reaching Killarney inlet was a relief. It was called Shebahonaning then, an Algonquin word meaning "safe canoe channel." But, of equal significance to the voyageurs, it was the halfway point of their 1,600-kilometre (990 mi) journey between Montréal and the head of Lake Superior. In 1790 their employer, the North West Trading Company, built a fort at this midway location, on La Cloche Island, which served as a canoe service station as well as an Indian trading post. The men often made camp here as well. They seldom slept for long though, usually rising at three in the morning and paddling for several hours before stopping for breakfast. But in the evening they took time to eat a supper of dried peas, pork and sea biscuit. Then, as daylight faded, they settled down for a leisurely smoke on their long clay pipes.

Thanks to the preservation of areas like Killarney, today's campers can enjoy much the same wilderness experience. Earlier on this summer day the three young boys pulled their canoe up in a sheltered bay that hadn't changed much since the voyageurs camped there 200 years ago. The only sign of civilization was a tidy circle of rocks, a fire pit left by former campers.

As the night closed in they lay in their sleeping bags with the campfire dimming and darkness creeping over them. They told each other stories of monster muskie and gigantic moose, legends that have long lured sportsmen to Killarney. Their laughter filled the air, and even though they could see the glow of other campfires flickering across the lake, they felt very much alone in the wooded wilderness.

Canoes at the ready, Killarney Outfitters, just west of the park.

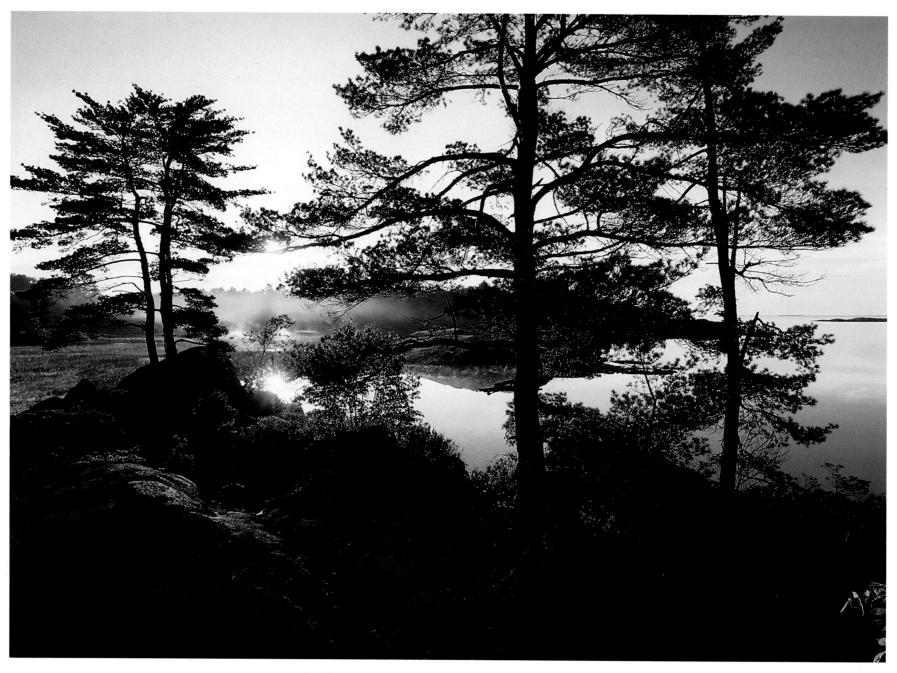

Daybreak in Killarney Provincial Park.

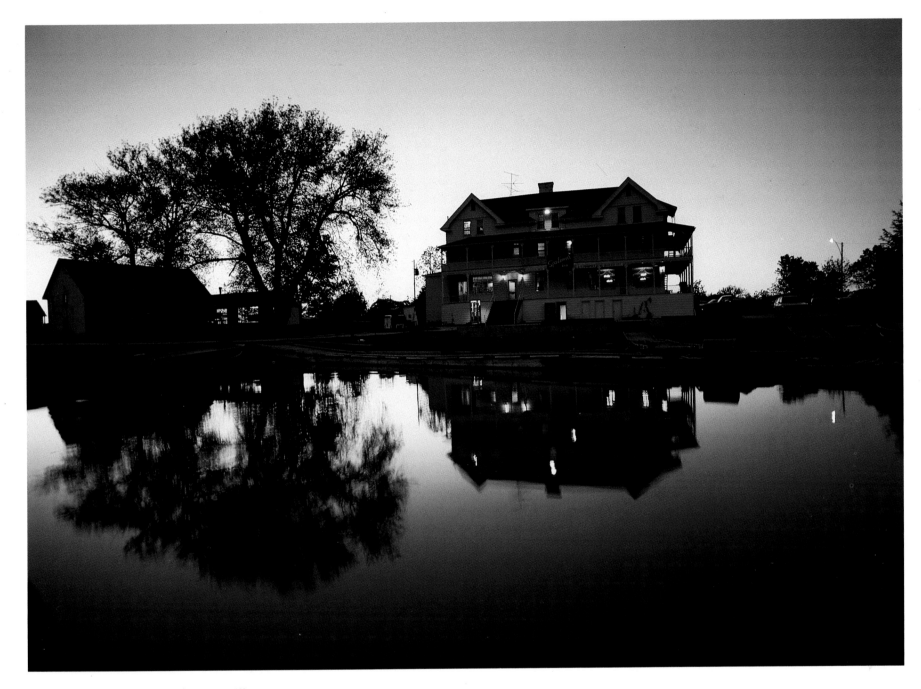

Twilight at the Sportsman's Inn, Killarney.

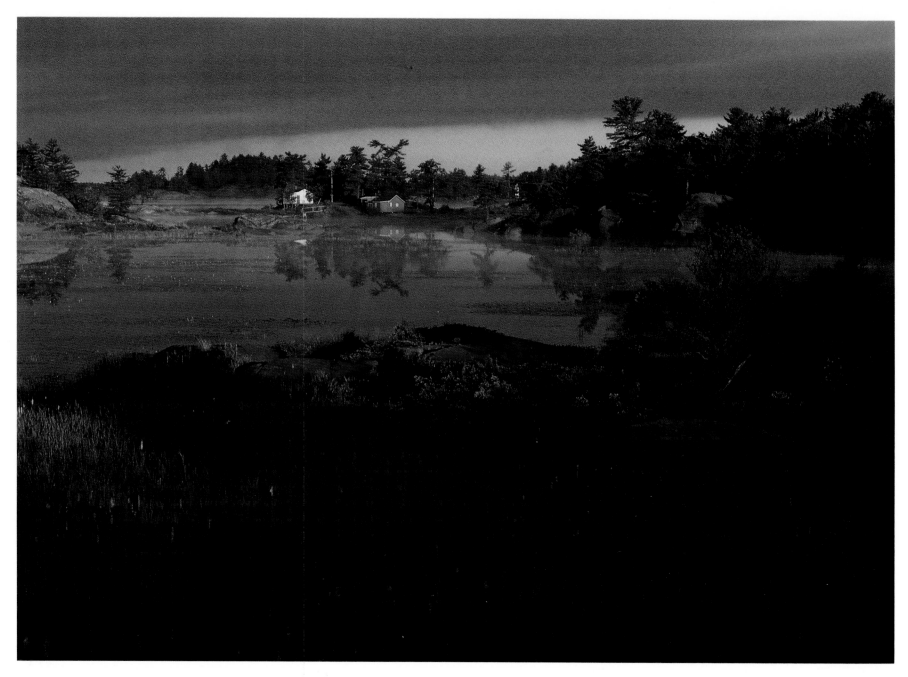

A misty morning north of Killarney.

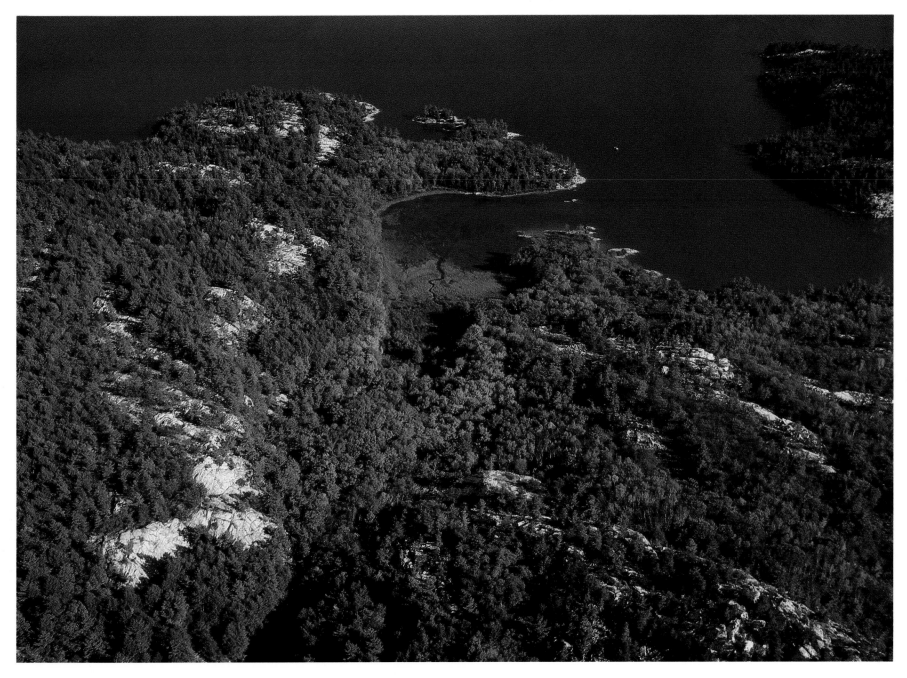

The quartzite hills of the La Cloche Mountain Range.

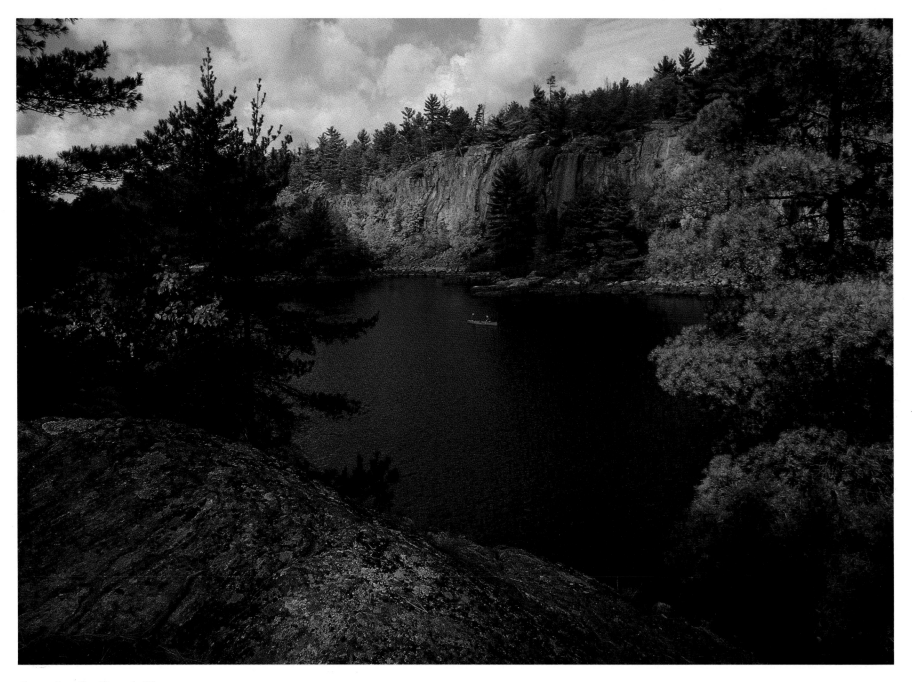

Canoeing the French River.

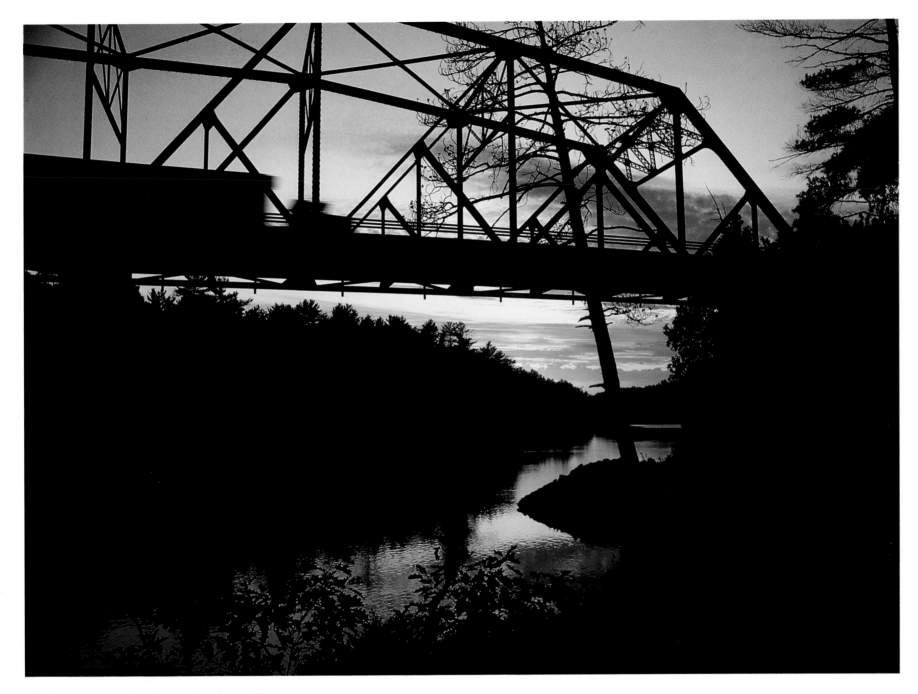

The French River bridge on Highway 69.

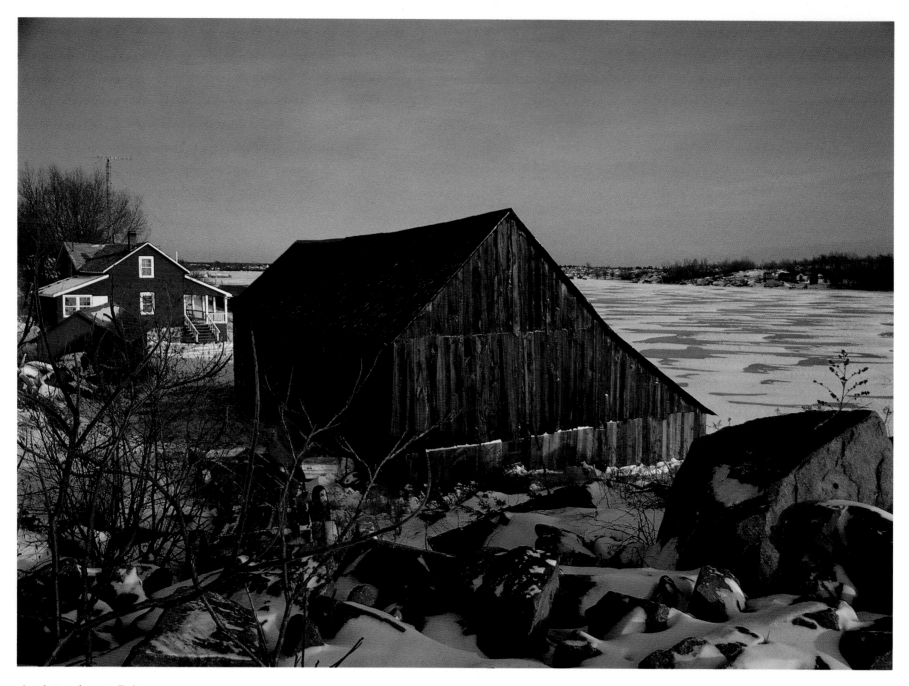

A winter day at Britt.

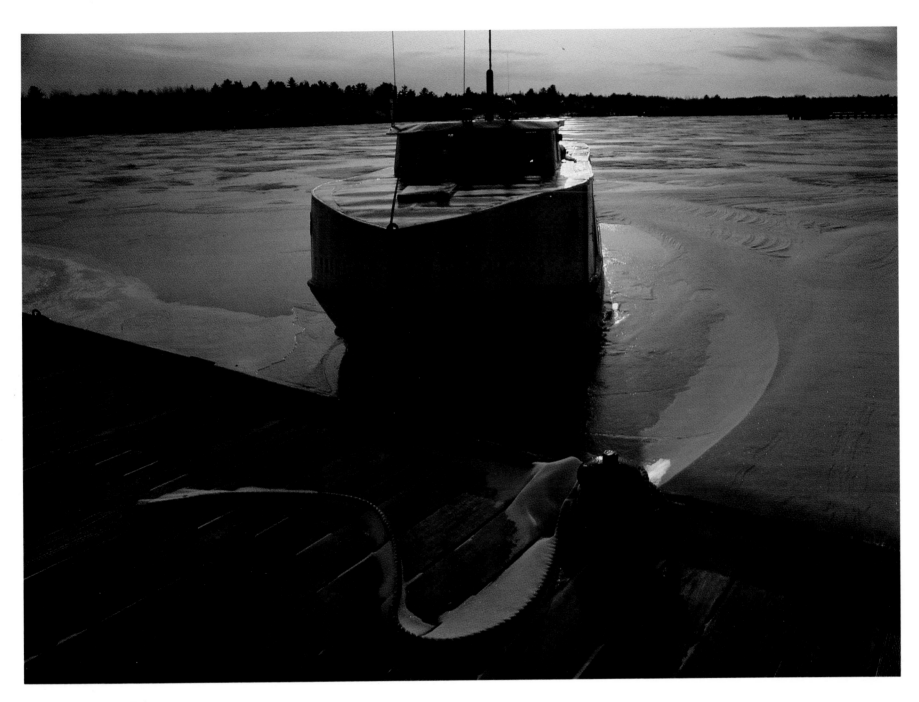

Ice marooned at Britt.

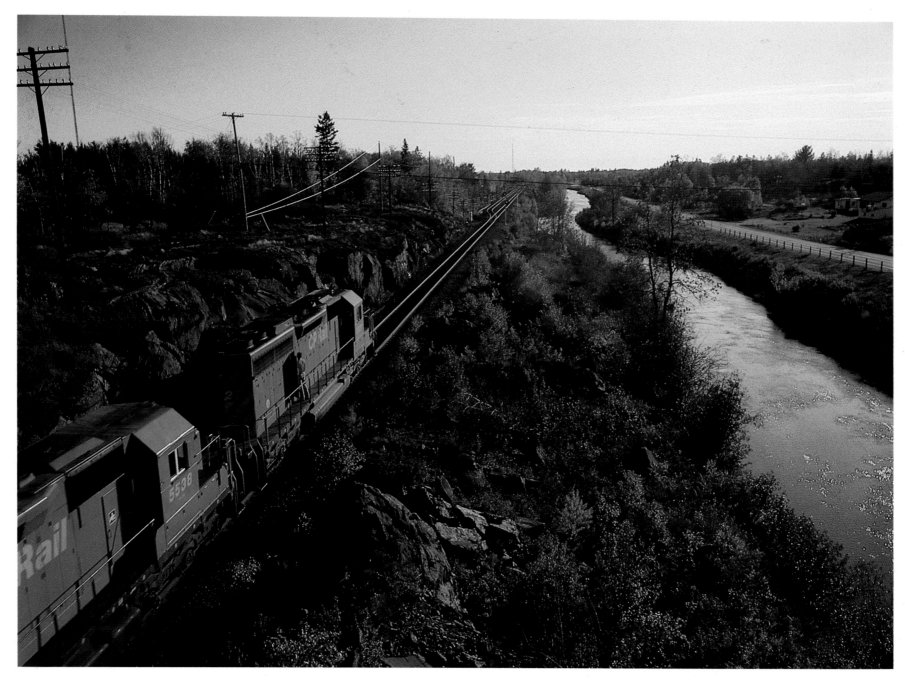

Still River at Britt.

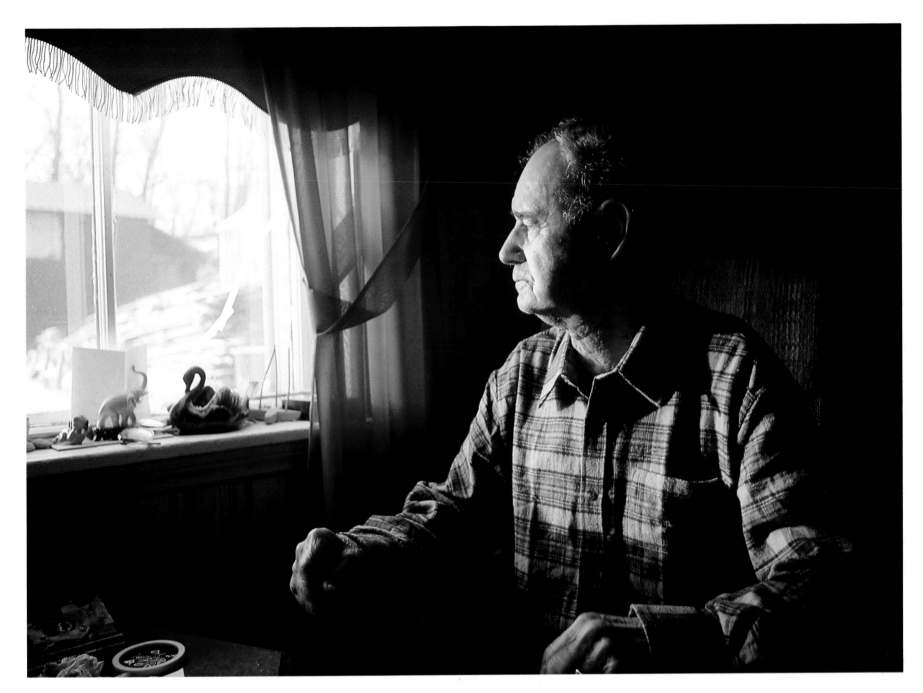

Britt's oldest inhabitant, Elmer Charette.

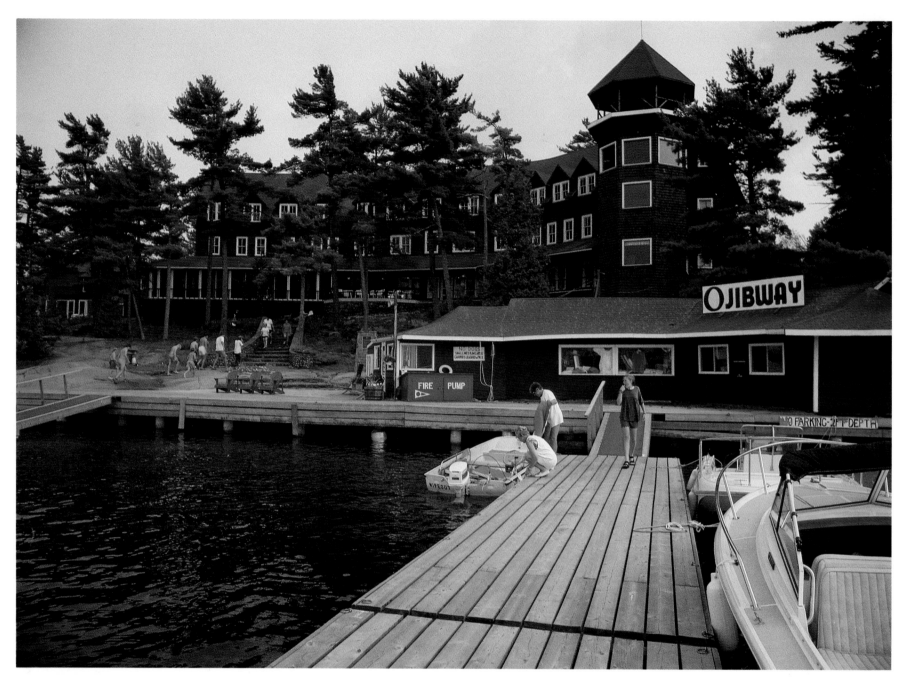

The Ojibway, gathering place for island cottagers, at Pointe au Baril.

THE OJIBWAY

The view from the upper-storey bedroom of the Ojibway Hotel has barely changed since the early 1900s, when the hotel first opened and became the busy hub of island summer life at Pointe au Baril. Through the dusty windowpane is a scene of sparkling water with a smattering of thinly forested islands, their twisted pines bent against the wind. There are a few more cottages now, and the boats are bigger and noisier than the sturdy dinghies and mackinaws that would drift into view back then, but the old wooden-frame hotel with its Victorian turret and sprawling presence looks about the same.

This tiny bedroom hasn't been slept in for almost 30 years. It is dark and dingy, dank with mildew. In it, an old iron cot still stands as a ghostly reminder of days past, when vacationers came from American and Canadian cities for a taste of "the bracing, life-giving air of Georgian Bay." Back then, little time was spent in the bedroom. Guests preferred to write letters and read on the breezy veranda, or head off to a remote gazebo for quiet moments of meditation — perhaps to ponder their good fortune at being in this glorious Canadian northland.

For the men who came to the Ojibway hotel the main lure was fishing. The hotel brochure proclaimed, "Fishing is the Chief Sport among the islands. Bays and channels are full of Black Bass, Pike, Pickerel and the famous fighting warrior the Muskalonge!" The daily catch was brought to the dock in late afternoon for the admiration of all, and then taken to the kitchen to be cleaned and cooked. The hotel boasted of cuisine that was "unsurpassed by any hotel on Georgian Bay." Such accolades were certainly due the famous roasted Muskoka leg-of-lamb, a regular menu item, and the pies made from freshly picked blueberries that melted in your mouth. The dining room

itself was enchanting, with its woodsy interior and the musky scent of sweet grass from placemats made by the local Ojibwa.

The unhurried pace at the hotel was typical of summer life, when women wore long dresses and spent lazy afternoons on rocking chairs. Hotels were regarded with almost the same reverence as sanitoriums, and guests booked in to rid themselves of ailments and to escape the filthy evils of city life. By 1910 the *Canadian Summer Resort Guide* listed 22 hotels and cottage resorts around Georgian Bay.

In 1921 a dance pavilion was built, and it soon changed the refined tempo of hotel life. From then on cottagers and guests gathered on Saturday night for the weekly dance — the social event that dominated afternoon-tea chatter for days beforehand. The women twisted their hair into topknots, donned slinky gowns and whirled about the wooden dance floor with men in high collars and white flannels.

Following the Saturday-night frivolities, things would settle to a simmer on Sunday. This was a day of rest, when even fishing was considered too active and irreverent. The store was closed, and the only event was a worship service held on the front rock.

Looking out from the second-storey hotel window today, a different pace of life is evident. Children run past with tennis racquets in hand; young mothers in bathing suits swerve up to the gas pump in their metal runabouts; a teenager, late for work at the grocery store, races full tilt along the wooden dock. This second floor has been closed off as a fire precaution, and the hotel hasn't operated since the early sixties, but of all the great hotels that dotted the northern lakelands, the Ojibway is one of the few that survives in any form. Today it's a cottager-run club,

Naiscoot Fishing Lodge at Pointe au Baril.

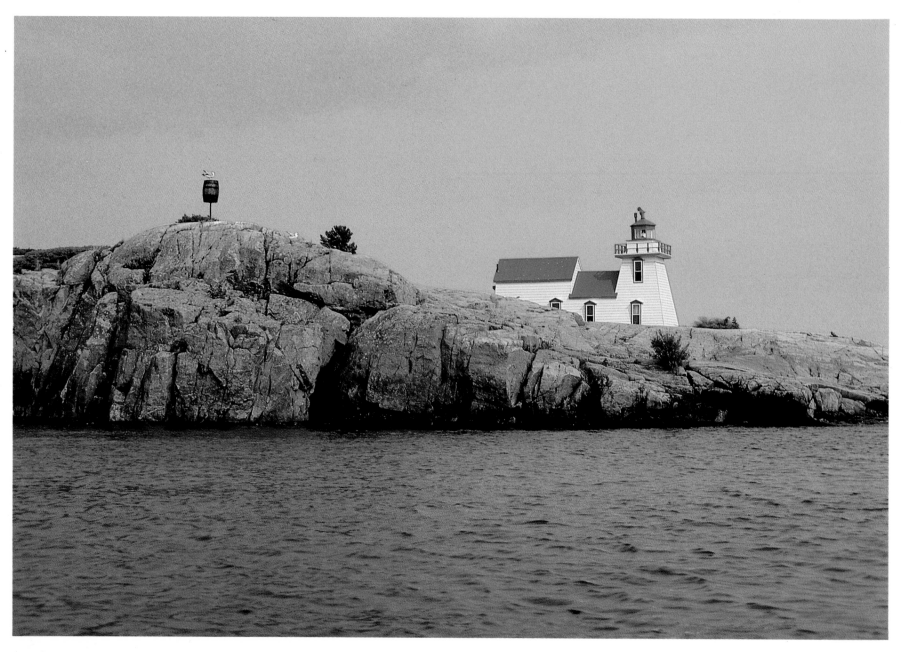

The lighthouse and the ''baril'' at Pointe au Baril.

a gathering place of a different sort, but still the hub of island summer life at Pointe au Baril.

The Ojibway story is immortalized on a stone cairn in front of the hotel. It reads: "At the turn of the century in a sparsely settled wilderness, Hamilton C. Davis built the Ojibway Hotel (1906), opening the magnificent sweep of Georgian Bay to women in long dresses and men in straw hats and spats who rode in long wooden launches and enjoyed the summer pleasures of the day. When the hotel closed in the early 1960s a group of islanders purchased the property and since that time the Ojibway has operated as a non-profit, open membership organization. During the summer young islanders run the many recreational activities and services for the benefit of Ojibway members. Tales of Champlain, of Native Tribes and of more recent heroes enrich the memories shared by many generations of islanders for whom the Ojibway dock will always mean 'home port'. Grateful thanks to all those past and present who have made the Ojibway the central meeting place and symbol of summer life in Georgian Bay."

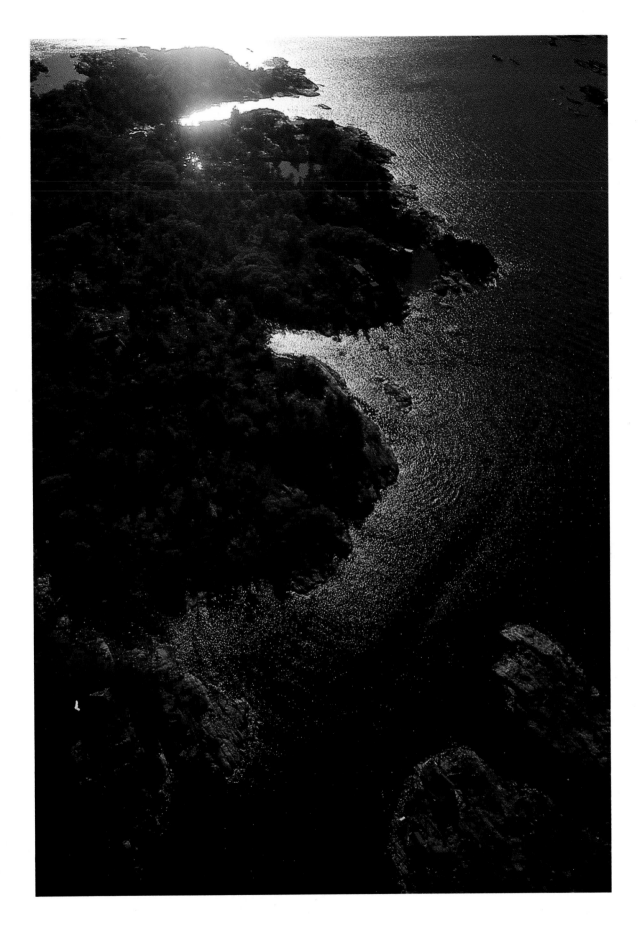

Channel entrance to Pointe au Baril.

Fun at the Winter Whirl, Pointe au Baril Station.

Island cottage at Pointe au Baril.

Snug Harbour.

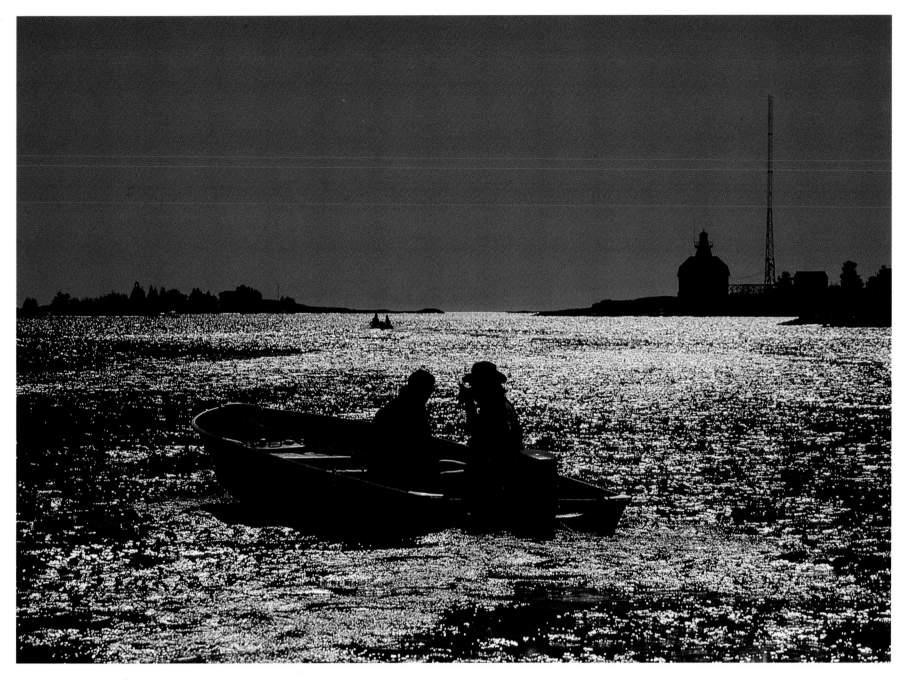

Silver water at Snug Harbour.

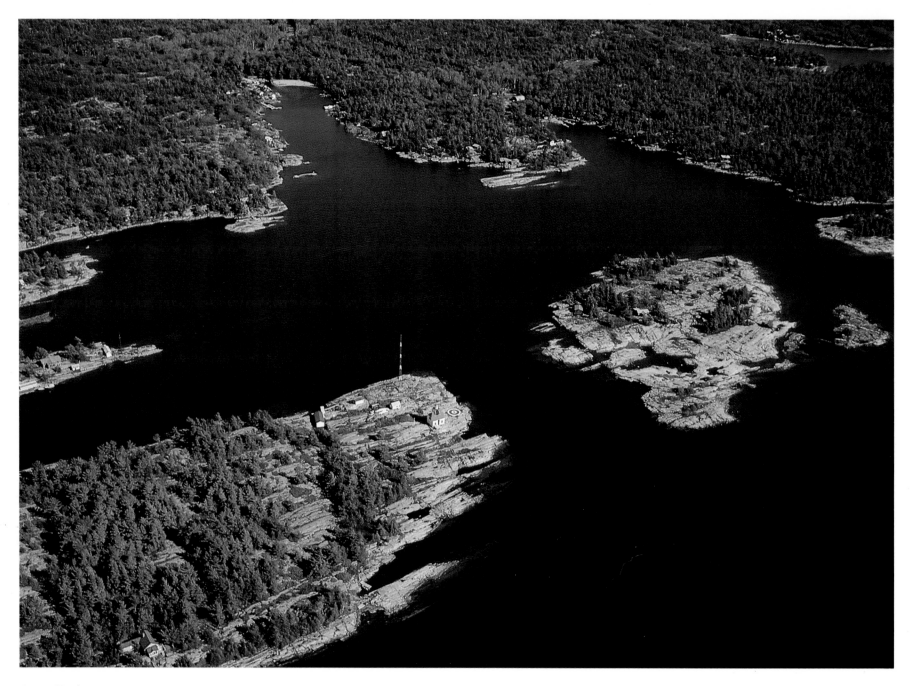

Snug Harbour.

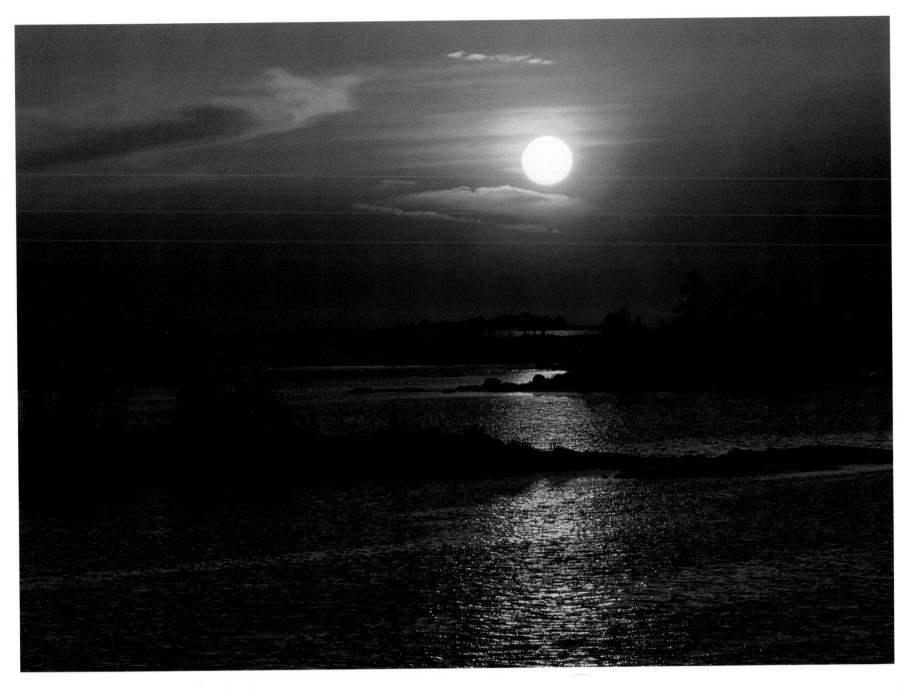

Summer sundown in the 30,000 Islands.

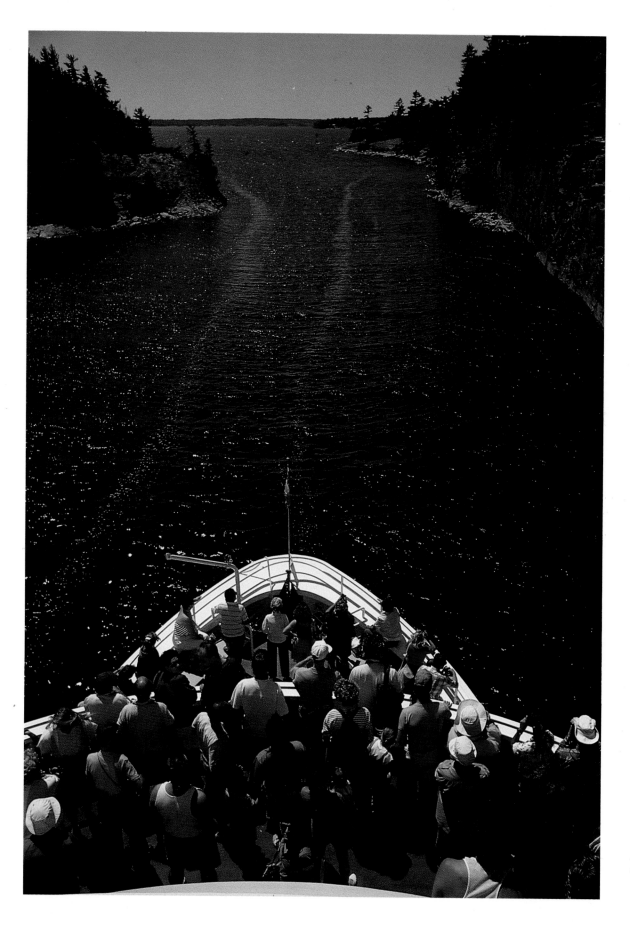

Heading into Hole-in-the-Wall on the Island Queen *cruise ship out of Parry Sound.*

30,000 ISLAND CRUISE

The group peering from the bus window as it roars up Highway 69 have come from Germany to see Ontario's famous cottage country. As they cross the bridge at Waubaushene they catch glimpses of hump-rocked islands and sun-sparkled waters, the first hint of Georgian Bay. Then for miles the road curves away from the shore, passing through rock cuts of pink granite, tall stands of pine and small inland lakes. At Parry Sound the bus turns off the highway and the passengers notice a huge water tower with large blue letters announcing the "Home of Bobby Orr and the 30,000 Island Cruise." They nod knowingly to one another, not because they have heard of Bobby Orr, but because this is the cruise they read about back home, the cruise that rivals their famous Rhine River cruise, the reason they have travelled north from Toronto for two and a half hours on a midsummer day.

"We're better known in Europe than here in Ontario," says Ron Anderson, the owner of the *Island Queen*, a 550-passenger cruise ship that carries visitors through this maze of islands and shoals known as the 30,000 Islands. (In reality, there are closer to 100,000 islands scattered along the shoreline from Waubaushene to Killarney.) Offering three-hour trips twice a day from May until October, as well as sunset and special Festival of Music cruises, the *Island Queen* carries over 60,000 passengers each season. "We have people come from everywhere in the world," says Anderson. The handsome 132-foot tour boat is the fifth one that he has operated since he and his father started the cruise line in 1968 with two small tour boats left over from Montréal's Expo 67.

At the helm on this summer day is Reg Greer, a portly, ruddy-cheeked captain who has been sailing Georgian Bay for 40 years.

He has been working the 30,000 Island cruise since it began and is still so enthusiastic that he blasts his boat whistle every time he sees cottagers racing down to the dock to wave him by. At one spot he looks for the dancing dog who regularly whirls about with delight as the *Island Queen* cruises past. Today the dog fails to appear and Reg is disappointed. But further along, his own doctor doesn't let him down. He's there as usual, playing his bagpipes on his cabin deck while the passengers listen and applaud.

As the boat turns to enter the narrow Waubuno Channel, the commentary on the public address system tells how this was once a route taken by the old wooden side-wheel steamers which sailed from Collingwood to Parry Sound in the mid-1800s. The name Waubuno means "soft west wind" in Ojibwa, but it is better known as the name of a steamer which mysteriously disappeared on November 21, 1879.

The autumn of 1879 had been a violent one. Lashing waves and heavy winds had kept steamers stormbound, preventing them from their regular runs across the Bay. For 14 years the 135-foot steamer S.S. *Waubuno* had been a lifeline between Collingwood and Parry Sound, keeping the north shore supplied with food and livestock. At four o'clock on the morning of November 21, after waiting in port for several days and listening to the grumbling of passengers and crew, Captain George Burkett decided to sail, for this was to be his final voyage of the season. His vessel was fully loaded with barrels of apples and flour, a team of horses, two cows, cages of poultry, a full crew of 14, and 10 passengers, including a young doctor and his new bride who were planning to set up a medical practice in the busy lumber town of Parry Sound.

Hugh Clairmont on the Island Queen *sunset cruise.*

The S.S. *Waubuno* never reached Parry Sound. Days later, when a lumber tug motored down the South Channel, she discovered wreckage all along the shore below Copperhead. The next spring the hull of the *Waubuno* was found upturned on what is now called Wreck Island. But no bodies were ever found and their fate has long been one of the great mysteries of Georgian Bay.

As the *Island Queen* leaves Waubuno Channel the commentary turns from this ghostly tale to more cheerful news about the great sailing waters of Georgian Bay, "considered by many to be one of the greatest sailing areas in the world." As if to prove the point, a double-masted schooner from Barbados sails by on the port side. She is such a beauty that cameras can be heard clicking from all three decks of the *Island Queen*.

At the end of the three-hour cruise the passengers disembark, talking animatedly in a variety of languages about their adventure. After the last of the group has left the ship, Captain Reg Greer, his captain's hat tucked under his arm, walks down the gangplank. A young German couple see him and come forward to shake his hand. "Thank you! Thank you!" they say. "It was *wunderbar*!"

Watercolours near Parry Sound.

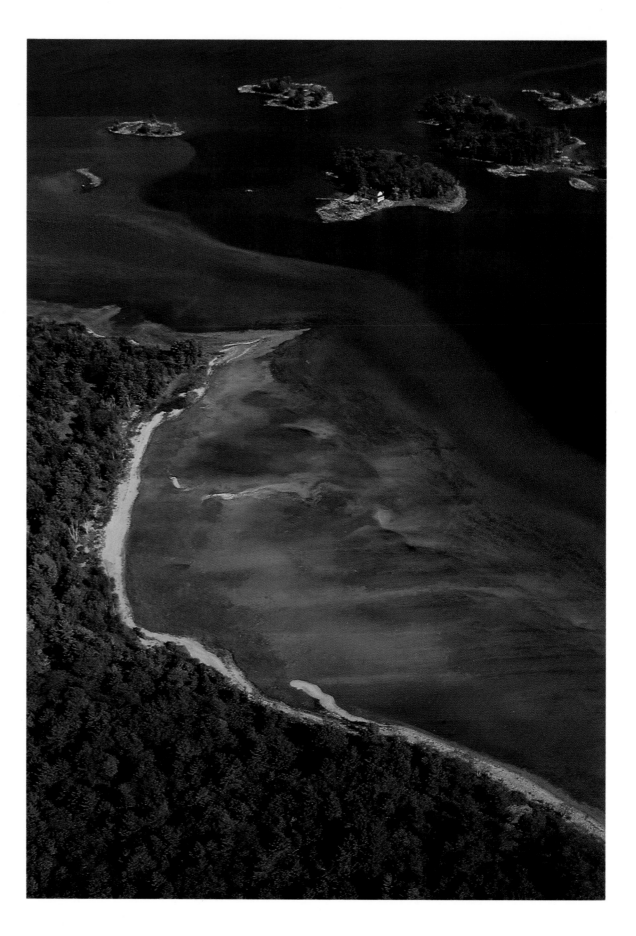

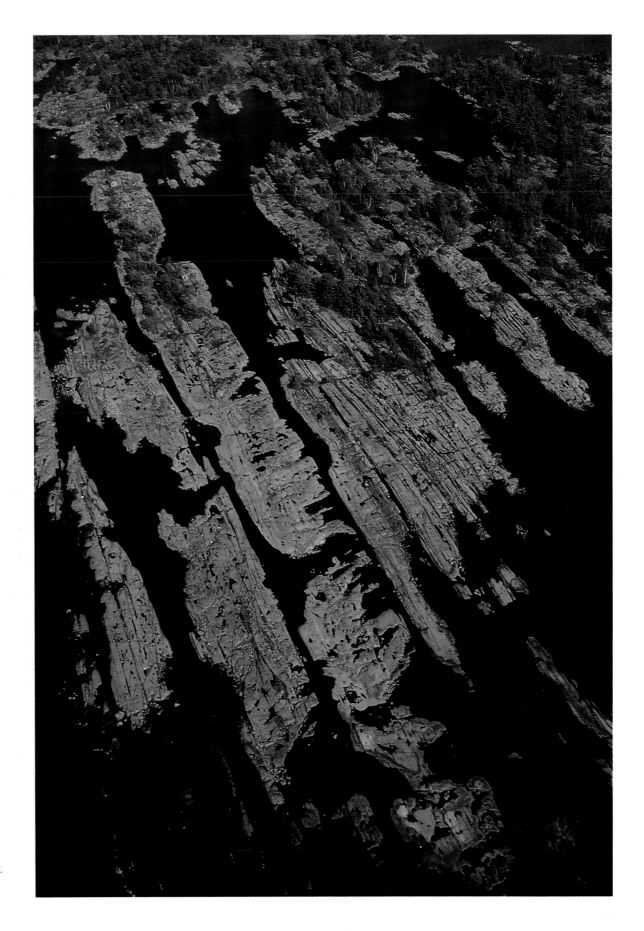

30,000 Islands.

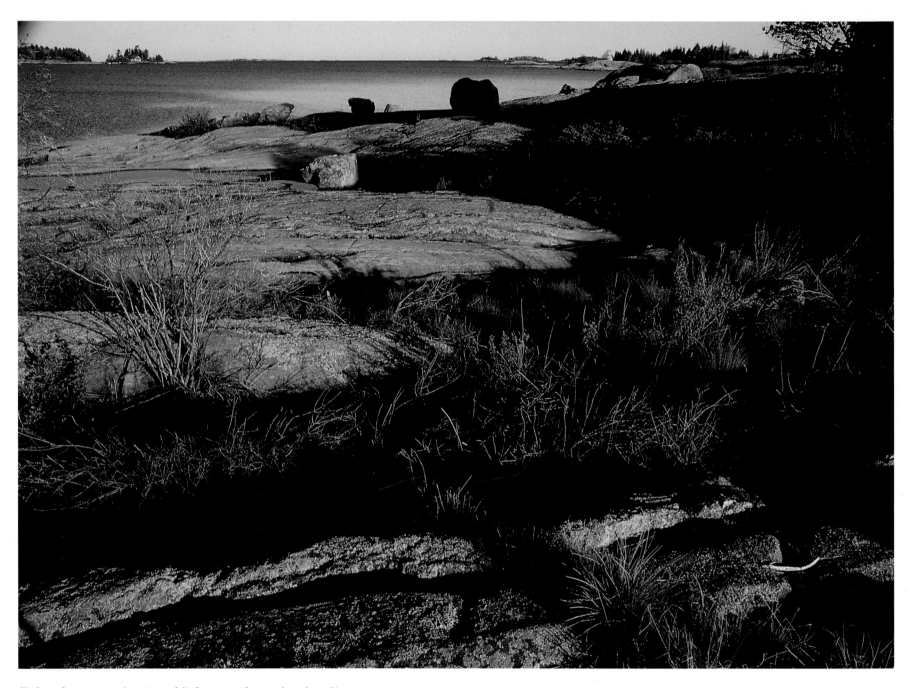

Tufts of grass and veins of lichen on the rocky shoreline.

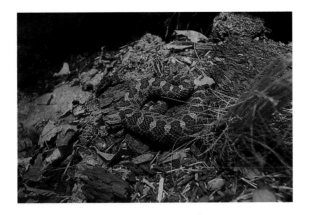

THE MASSASAUGA RATTLESNAKE

Trespassers will be forgiven IF —
1. they carefully extinguish their fire
2. they pick up and take with them all garbage
3. they do not disturb the large rattlesnake that lives at the base of the pine tree.
A sign posted on a vacant island near Go Home Bay

If there's one species of wildlife that is intimately connected to Georgian Bay, it's the massasauga rattlesnake. In fact, Georgian Bay is the only place in Canada where these indigenously venomous snakes exist. Over the years the massasauga has been the cause of islanders wearing rubber boots on dry summer days. It's the reason why, as toddlers, cottagers learn the "Georgian Bay Walk," a high-stepping gait that requires steely-eyed focus on the ground ahead. The mere idea of the snake's presence can turn brave men into weak-kneed wimps. This slithery 76-centimetre-long (2 1/2 ft) grey and brown-spotted reptile with a rattle on its tail that sounds like the loud buzzing of a giant bee can be dangerous, but the hazards have been greatly exaggerated.

The name "massasauga" is derived from Ojibwa words meaning "great river mouth," the location where these snakes were most likely found by early explorers in the region. There's a Rattlesnake Harbour named for them at the north end of the Bay, and now that they're on Canada's list of endangered species, these rattlesnakes are attracting more attention than ever.

Much of cottage legend and lore is based on encounters with nature and with wildlife sightings — the wilder the better. Sitting around the fire on a chilly August evening the conversation often turns to such subjects: the time when Uncle Rick found a black bear in the outhouse on a dark, moonless night; the day that a raccoon ate all of Grammie's peach pies on the kitchen windowsill; and who can forget Auntie Ruth's cocktail party when a huge rattlesnake was found curled up under the kitchen table?

Over the years the timid massasauga rattler has been much maligned. One of the most prized of early cottage gadgets was a forked "snake stick" which was used to capture the rattlers and then notched for every kill. Fear of snakes, however, is sometimes enough to deter visitors from ever returning to Georgian Bay. A story is told about a snake encounter that took place in the Sans Souci area one summer day in the early 1900s. It seems that a large, handsome, harmless fox snake made its way towards the open mouth of a tent that had been erected on the northwest point of Menimmenis Island. The tent was occupied at the time by the wives of two sport fishermen from Buffalo, New York, who owned the island. The snake poked its head inside, then quickly retired into the underbrush without knowing it was the cause of the shrieks of fright coming from the tent. Unable to persuade their wives of the delights of summering on Georgian Bay, the men never returned.

Several myths persist about rattlesnakes. It's not true, for instance, that they always travel in pairs, so if you see one, another is bound to be lurking nearby. It's also not true that they leap through the air like flying squirrels on the attack. And a

The Massasauga Rattlesnake.

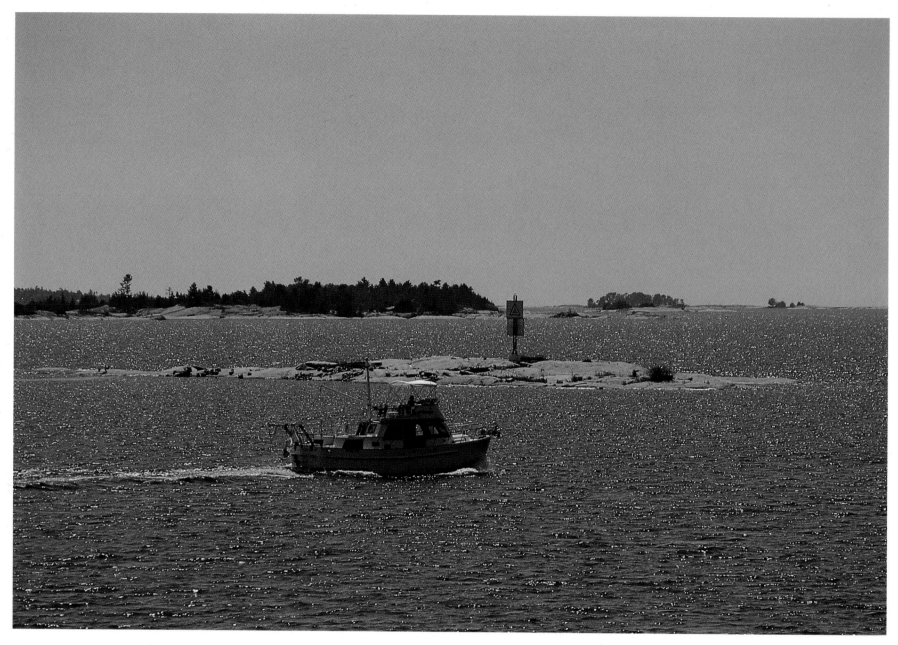

The shimmer of midsummer heat.

rattlesnake will nòt avenge the death of its mate. In fact, it will never chase you, preferring instead to slide off unnoticed into the tall grass. The venom of most rattlesnakes is not strong enough to kill a human instantly. Their venom is immediately lethal only if you're another snake or a rodent. But a bite does require immediate medical attention, especially for children.

Today, with greater knowledge of these shy creatures who help control our rodent population, cottagers are coming to accept their presence and to share their environment. Programs sponsored by government ministries, zoos and wildlife organizations are now tracking massasauga rattlesnakes to learn more about their habits, in the hope of preventing their extinction.

The Canadian Coast Guard Base at Parry Sound.

Pilings from the old freight sheds at the steamer dock in Depot Harbour.

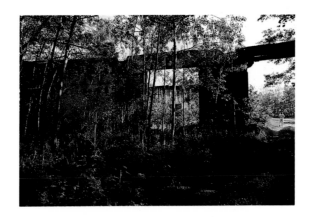

GHOST TOWN

V-J night, 1945, the end of World War II. Everywhere fireworks exploded into the sky in celebration of the event. On this same night, the little town of Depot Harbour on Parry Island had its own explosion, a fire that burnt the town to the ground. Cordite, a smokeless gunpowder composed chiefly of nitroglycerin and guncotton, had been stored in a grain elevator. Its sudden ignition caused a fire of such intensity that 6-1/2 kilometres (4 mi) away, in Parry Sound, you could read by its light. Later it was said that two men were seen running from the elevators just before the explosion. The fire was the final deathblow to the town that at one time had been a bustling railway terminus with a population of 3,000.

The town was built in the late 1800s by Ottawa lumber tycoon John R. Booth, who was just completing a railway that ran from Ottawa through Algonquin Park and up to Georgian Bay. His Ottawa, Arnprior & Parry Sound Railway was constructed to access his lumber interests in Algonquin Park and also to give grain growers in the West a direct route to Ottawa, where connections could be made to Montréal and on to Atlantic Ocean ports via the St. Lawrence. He originally chose Parry Sound as the terminus for his railway, but when that town demanded too much money, he looked elsewhere. He discovered a place on nearby Parry Island, an Indian reservation which had one of the best natural harbours in all the Great Lakes. He decided to lease the land from the Indians and build his railway town here, naming it Depot Harbour.

In 1897 eighty-nine family homes were built, as well as a three-storey wooden hotel for transient workers. There was also a general store and butcher shop, a post office, three churches, a town hall, railway yards, and a roundhouse. Enormous freight sheds were built on pilings in 9 metres (30 ft) of water, and grain elevators large enough to hold a million bushels of grain.

Everyone in Depot Harbour worked for the railway, and the only way into or out of town was by rail or by ship. Railway employees worked long, hard hours. During summer, when shipping was at its peak, the elevators and sheds operated 12 to 18 hours a day, except for Sunday, when the trains didn't run. For a while it seemed as if Depot Harbour would become the busiest port on the Great Lakes.

Then, in 1928, the Canadian National Railway took over Booth's Ottawa, Arnprior & Parry Sound line and relocated its facilities. Five years later, when a flash flood wrecked a trestle in Algonquin Park and the government refused to repair it, Depot Harbour's lifeline was severed. The route through Depot Harbour was no longer the shortest route to New England.

During the second half of World War II, many of the grain elevators at Depot Harbour were torn down. Those still standing were used as storage sites for the explosive cordite. Depot Harbour's contribution to the war effort cost it its life.

Today Depot Harbour is one of Ontario's most intriguing ghost towns. Remains of the roundhouse's stone walls still stand, though birch trees have grown through its roof. Down at the docks, a few fishermen sit languidly catching rainbow trout amid the abandoned pilings. Weeds grow in the long-gone gardens of former company houses. There's little to remind us that this was the place where lumber tycoon John R. Booth once dreamed of creating the biggest and best railway town in all of Georgian Bay.

Remains of the railway roundhouse at Depot Harbour, Parry Island.

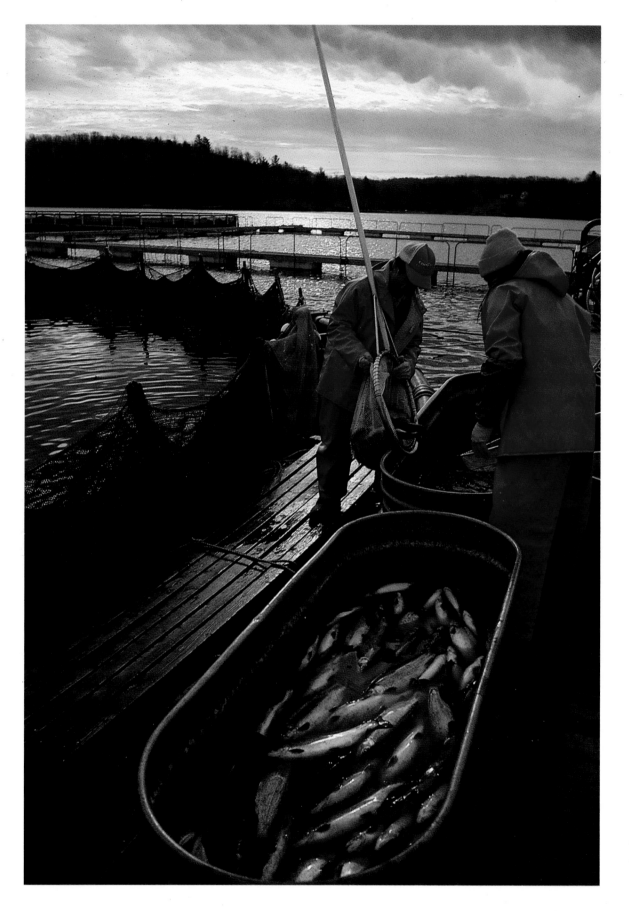

Commercial fishing for lake trout at Depot Harbour.

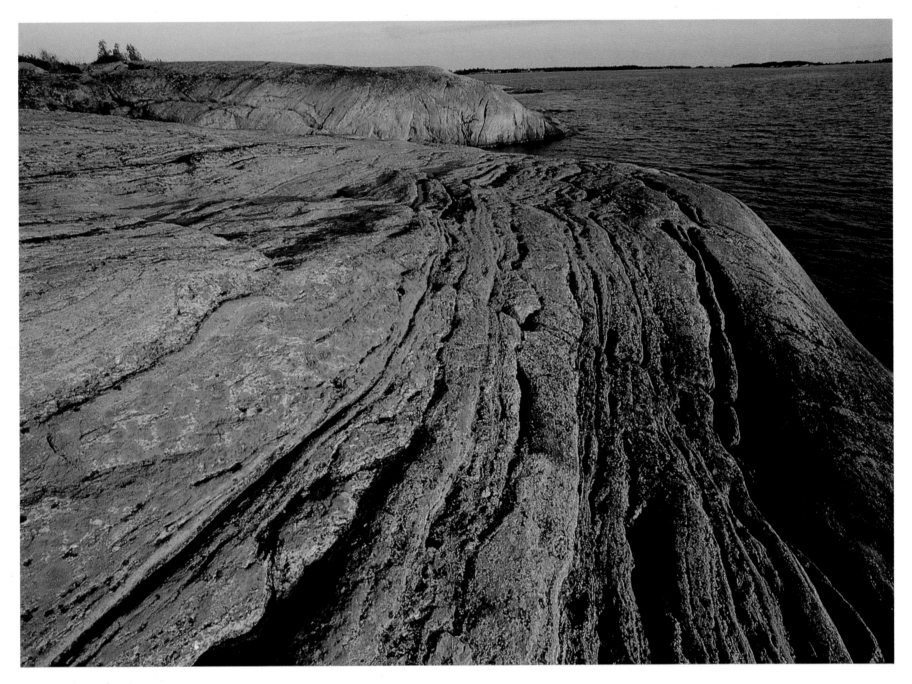

Lichen along the shore.

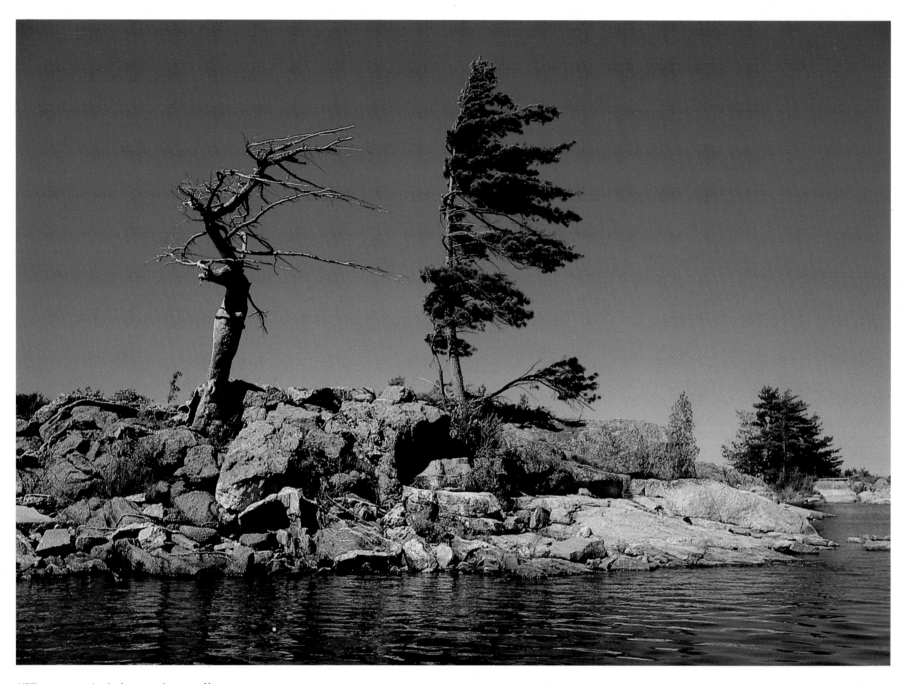

"The west wind shapes the tree."

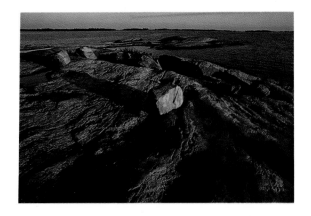

TERRE SAUVAGE

It was the summer of 1913 and 30-year-old A.Y. Jackson had just quit his job as a commercial artist. His goal was to become a full-time painter and to move to the United States. A few months earlier he had met other artists at the Arts and Letters Club in Toronto, and one of them, Lawren Harris, had persuaded him to stay in Canada for the summer. He spent it at Georgian Bay, a favourite place for young Toronto men to go fishing and camping, but an unlikely subject for a painter in those days. Other Canadian artists of the time, schooled in the European tradition, were painting pastoral farm scenes dotted with cows and windmills, gentle landscapes that had little to do with the reality of Canadian geography.

The summer of 1913 was idyllic. Jackson swam, fished, paddled, explored, and looked for wildflowers. His home that summer was a dilapidated bathing shack near Go Home Bay. In September, after everyone had gone, he began to paint. The days turned colder, and it became more and more uncomfortable in the old shack. But his surroundings were so stimulating that he huddled on rocky ledges, sketching, watching the weather change, capturing the moods of the Bay. His fascination with the shifting winds prompted him to write: "Every wind brought its change of colour — the North wind with everything sharply defined and the distant islands lifted above the horizon by mirage; the South wind — the blue giving way to greys and browns and the water washing over the shoals; and the West wind best of all — sparkling and full of movement. Only the East wind seemed to kill all incentive to paint, which seldom lasted."

One chilly September day while Jackson was busy trying to fill the cracks between the boards of his shack, a motorboat appeared. At the helm was Dr. James M. MacCallum, a medical doctor who had built a cottage two years earlier at Go Home Bay. As a patron of the arts he had already befriended Arthur Lismer and was working with Lawren Harris on plans for an artists' studio building in Toronto. Understanding how difficult it would be for Jackson to continue living in his drafty bathing shack, MacCallum offered Jackson the use of his West Wind Island cottage until the end of October.

As they motored across the water toward the MacCallum cottage, the two men talked of Jackson's plan to go to the United States. "If all you young fellows go off to the States," the doctor declared, "art in Canada is never going to get anywhere." MacCallum then made him another surprising proposition. If Jackson would take space in the Toronto studio that he and Harris were building, he would guarantee Jackson's expenses for a year. Jackson accepted.

At the end of a fruitful autumn of sketching, Jackson returned to Toronto and painted "Terre Sauvage," a broody oil of Georgian Bay with heavy clouds, garish red maple trees and bright green pines. The critics were unkind and later labelled it the most radical painting in an exhibit of "art gone mad."

Despite the critics, over the next few summers Georgian Bay became a favourite sketching ground for A.Y. Jackson and the group of artists who banded together in 1920 to become the Group of Seven. The original members were Jackson, Franklin Carmichael, Lawren Harris, Franz Johnston, Arthur Lismer, J.E.H. MacDonald and Frederick Varley, a group united by their belief that the romantic and mystical northern landscape is what makes Canada unique. They painted it with passion. And today, among Canada's most prized canvases are the Group's moody landscapes of Georgian Bay.

Boulder-strewn islands.

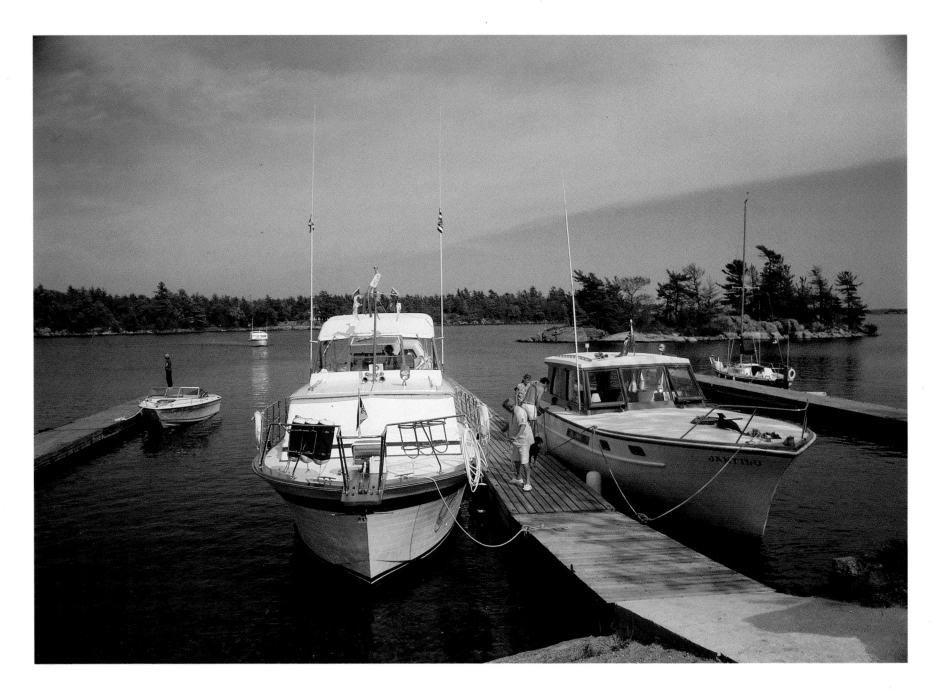

The docks at World Famous Henry's Fish Restaurant on Frying Pan Island at Sans Souci.

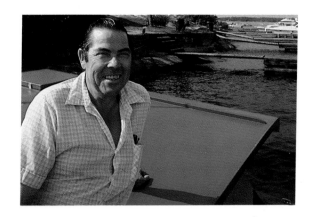

WORLD FAMOUS HENRY'S FISH RESTAURANT

Wiping his hands on the white apron tied around his waist, Henry LePage moves purposefully from one huge frying kettle to another. The inviting smell of frying pickerel wafts through the busy kitchen as a voice crackles over the CB radio: "Forty-foot cruiser coming in with ten people aboard. Can you feed us?"

Feeding ten is nothing to Henry, who claims his record is 415 people in one afternoon. In his restaurant on Frying Pan Island, in the Sans Souci area, he can seat 52 in the dining room and another 100 at picnic tables out in the tent. At peak times waitresses sprint from the kitchen carrying enormous trays. With a practised leg swing they kick open the screen door and enter the noisy dining tent. Boats converge here from all points on the Bay to tie up at one of the eight 36-metre-long (120 ft) docks and tuck into an all-you-can-eat fish dinner. Emblazoned on the roof are huge white-painted letters: WORLD FAMOUS HENRY'S FISH RESTAURANT.

In this part of Georgian Bay, Henry has been "world famous" at least since he opened his restaurant in 1978. It has always been a family affair, with his ten children helping out and his wife Edith baking bread, coconut cream pies and her famous butter tarts. At first Henry stayed open year-round and snow-mobilers could come across the ice for a winter fish dinner. Then he decided to close after Labour Day and spend the winter at home in Penetanguishene.

Some of Henry's island neighbours — cottagers who come here for peace and quiet — speak of the success of this enterprise with little enthusiasm. But Henry is almost too busy to notice. Every morning well before dawn he sets off for his fishing camp at the Watchers Islands, where he hauls in his nets. Then he puts in a full day cleaning the pickerel and perch and supervising the kitchen help. By midnight he may still be at the stove, making fish chowder for the next day's crowd.

Henry's great-great-grandfather came to the military establishment at Penetanguishene during the War of 1812, and later worked as a blacksmith and fisherman. Back then, Georgian Bay seemed to have an endless supply of fish. Up until 1860 the commercial fisheries concentrated almost entirely on salted whitefish, loading brine-filled barrels for export south. But as soon as railway links and ice facilities came to the area, commercial fishermen were able to get fresh fish to market and the industry boomed. From base camps in towns like Collingwood, Midland and Penetang, the fishermen would set off in double-ended sailboats called "mackinaws" for their fish stations out on the islands. By 1890, 3,200 kilometres (2,000 mi) of nets were yielding 2.7 million kilograms (6 million lbs) of whitefish, trout and pickerel.

The fishing industry and enthusiasm for sport fishing probably brought more people to Georgian Bay than anything else. It wasn't until the 1960s that the fish populations began to decrease and commercial fishing went into a dramatic decline. The reasons, it seems, were a lack of control of commercial fisheries in the forties and fifties, and the arrival of the parasitic sea lamprey. Efforts are now being made to restore lake trout and whitefish populations.

"When I started fishing in Georgian Bay thirty years ago," explains Henry LePage, "there were thirty-five commercial fishermen in the area. Now there are only five, and only three of those are active. It seems to be a dying industry." Henry is doing his part to keep it alive, and catching prize-winning fish is still an honoured tradition in the LePage family. Adorning the dining-room walls in World Famous Henry's Fish Restaurant are a variety of hefty-looking mounted fish. Henry says proudly, "My son is a great fisherman. He caught every one of those."

Henry LePage of the World Famous Fish Restaurant

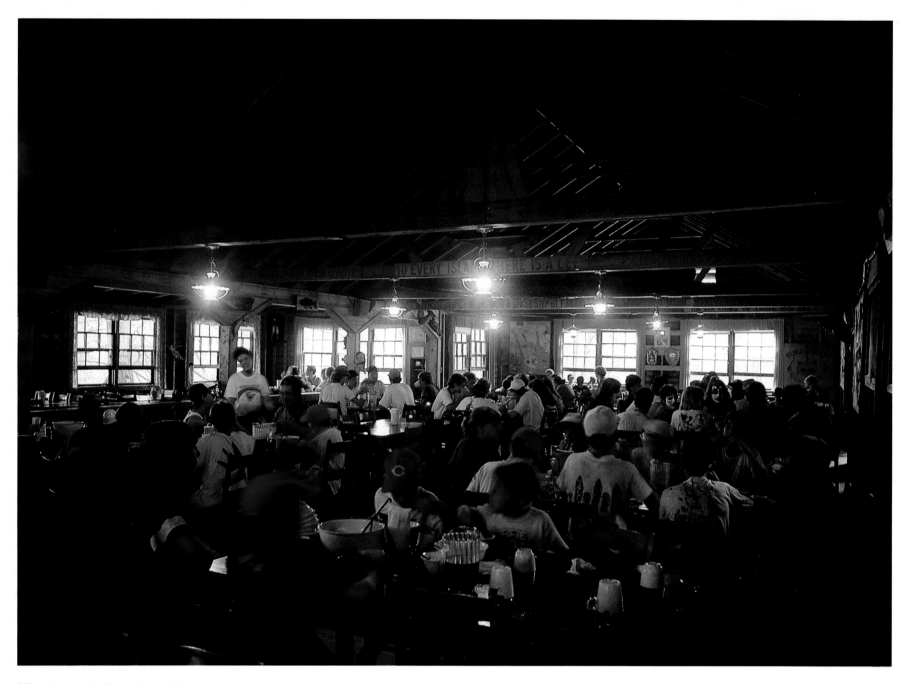

The dining hall at Camp Hurontario.

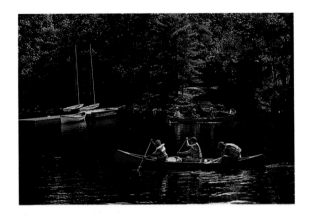

CAMP LIFE AT HURONTARIO

*Oh the Lord is good to me
and so I thank the Lord
for giving me the things I need
the sun, the earth, and the appleseed...*

The boys' voices rise in unison, filling the old wooden dining hall with pious noise. Almost a hundred of them have burst in for lunch on a hot August day. Another 80 are out "tripping" somewhere in the tangled bush of Georgian Bay. When grace is over, the raucous chatter begins. Soup is ladled into plastic bowls and bread stuffed into hungry mouths. Above the din, written on rafters that span the long room, are mottoes representing every camping season, sayings like "In Calm Water Things Reflect Most Clearly" that date back as far as 1949.

In the mid-1940s Birnie Hodgetts was a teacher at a private boys' school and spent his summers as the director of a boys' camp in Algonquin Park. A few years earlier, while on a fishing trip with his father in Georgian Bay, he had spotted an island he knew would make an ideal site for a camp. It had protected bays, swamp areas, high rocky plateaus and sheltered coves spread out over 121 hectares (300 acres) near the mouth of Twelve Mile Bay. All around it were domed islands of pink rock and beautifully clear green water.

He discovered that the mainland property used as access for the island was owned by a British colonel, a Boer War veteran who had been given the land as a farm grant by Queen Victoria but had never set foot on it. When Hodgetts wrote of his desire to buy the property and start a boys' camp, he received a return letter from the Colonel stating that he would be glad to sell, but only if the camp were restricted to "upper-class"

boys. A subsequent letter added a new proviso: an Anglican minister would have to be resident at the camp. Hodgetts refused both conditions, but in order to keep his camp dream alive, he continued correspondence with the Colonel. One day the Colonel wrote to say that he had moved to Mexico and fallen in love with Carmelita, a 19-year-old Mexican girl. But, he reported, she wouldn't marry him because he didn't have an English piano. Hodgetts quickly sent a wire to Mexico stating, "I'll send you the money to buy a piano and have it shipped from England if you give me the shoreline." And so the deal was done. For $650 Carmelita got her piano and Birnie Hodgetts acquired the land to start Camp Hurontario.

The camp has grown from those early days when 25 boys spent the summer helping build the cabins that still exist today. Back then, everyone arrived by steamer. As the old *Midland City* steamed in to the camp dock, the entire staff would jump nude into the water before she landed. Everyone still arrives by boat, if not by steamer, and nude bathing is still a ritual in this remote wilderness. Other things may change, but the philosophy of the camp has never altered. Hodgetts believed that camp life must be a break from typical school routine and urban life. There would be no reveille, no drills, no competition, no school games or team sports, no badges, no radios or televisions, no tuck shops and no care packages from home. Instead the boys would learn to single a canoe and roll a kayak,

Canoeing at Camp Hurontario.

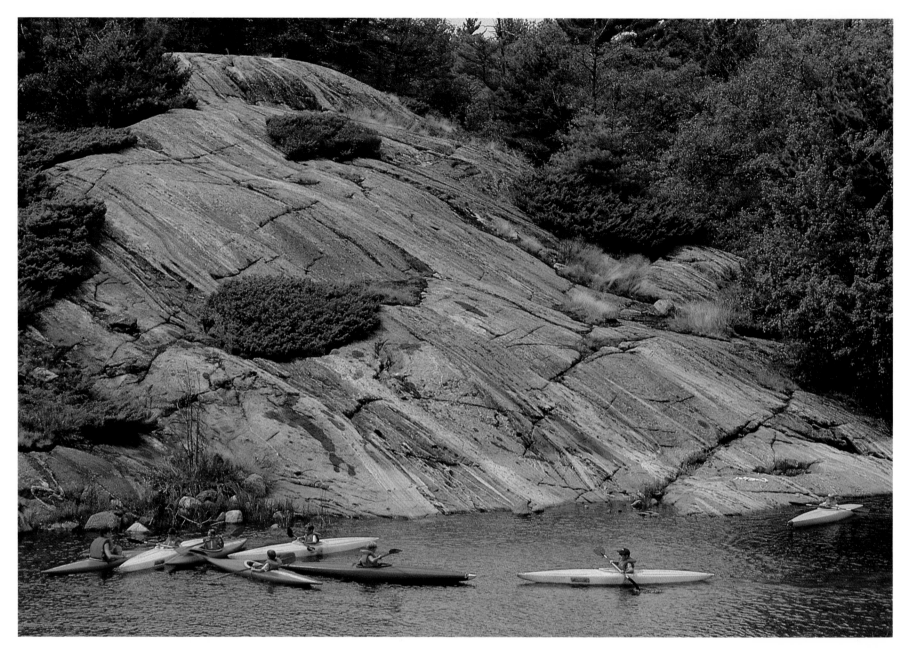

Kayak lessons at Camp Hurontario.

to poke around in swamps for lizards and snapping turtles, to tie fishing flies and catch fish with them, and to paddle among the thousands of islands and miles of channels that surround the camp property. And during Sunday services at Flagpole Point, the boys would learn to sit quietly for a few minutes and listen to the wind and water, to hear the message in their sounds.

As lunch hour ends on this August day the clatter of dishes being cleared rises above the boyish banter in the dining hall. Pushing themselves away from the long wooden tables, one

suntanned group of youngsters heads off to the Bug House to check the morning catch of toads and garter snakes. Others lope off to Sandy Bay to climb into kayaks, or to Smiling Pool to wade knee-deep among the tadpoles.

When Birnie Hodgetts died in 1987 he left a legacy — a generation of campers, now grown men, who return every summer to their own cottages on Georgian Bay. And at Camp Hurontario his spirit lives on. Scripted on a rafter in the dining hall is his first motto, dated 1949: "In the Boy is Seen the Man."

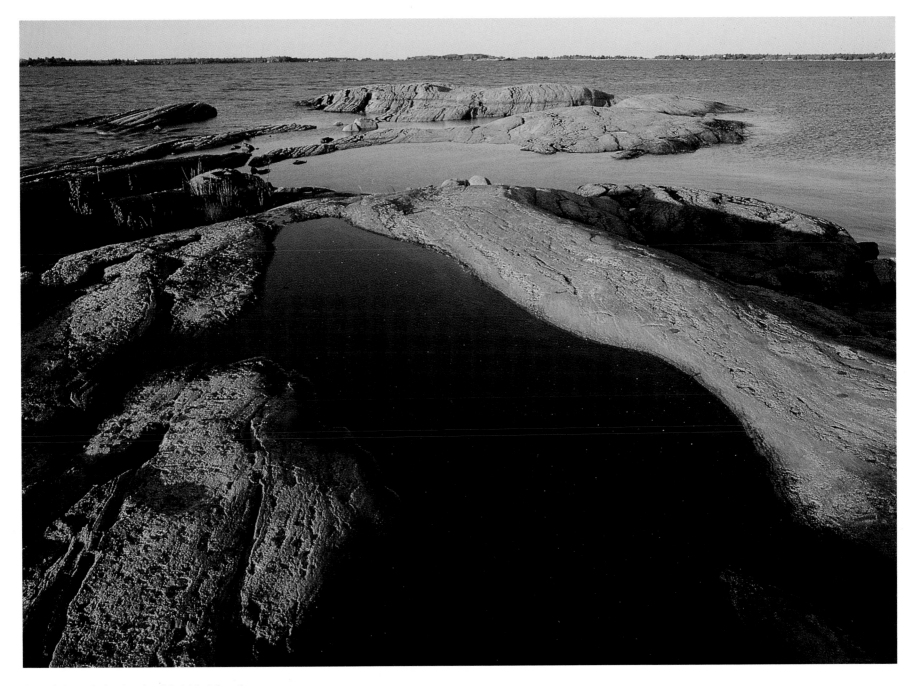

Low-lying rocks in the 30,000 Islands.

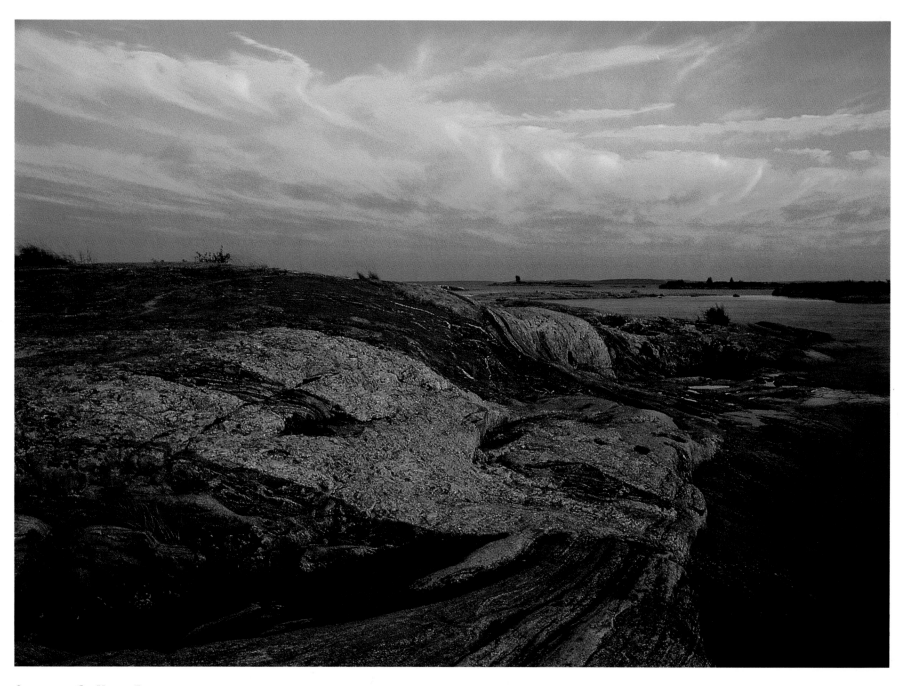

Sunset at Go Home Bay.

SUNSET AT GO HOME

She walks barefoot on the flat shoal that edges the shoreline of her island at Go Home Bay. All is silent except for the distant drone of open water, the ever-present reminder of nature's power. "My two favourite sounds are a cat's purr and the sound of open water," she muses while stopping to examine an ancient pine tree that has been upturned by a cyclone. Its massive root system thrusts skyward. Beneath it is bare rock, not a scrap of earth. It's a wonder that trees grow here at all.

The sun is beginning to sink against the flat horizon. A heron flies by, its graceful wings silhouetted against the orange sun. A gull cries out in the still air as the cottager turns and, as if led by lengthening shadows, walks toward her cottage. As long as she can remember, everything has come to a standstill when the sun begins its nightly descent into the Bay. The family gathers on the west-facing screen porch, hands warmed by coffee mugs, to talk and to keep a close eye on the unfolding spectacle.

Such reverence for nature's star performance is deeply rooted in the ethos of Go Home Bay cottage life. The first cottagers to come here were academics — scientists, biologists, doctors, nature lovers all. They came from the University of Toronto to form the Madawaska Club, named for their first choice of land along the Madawaska River. When lumbermen in that vicinity opposed their site, they abandoned it and applied to the Crown Lands Department for 1,000 acres at Go Home Bay. It was the summer of 1898 when 17 Madawaska Club men and 11 women first "camped" at Go Home. There were many discomforts, as well as more severe problems like food shortages, violent storms, illness and shipwrecks. The clubhouse built that first summer had five primitive cubicles where the ladies slept. The men put up tents on the flat rock out front.

Few members of the Madawaska Club had previous camping experience, but bound by their love of nature and spirit of adventure, they vowed, despite the hardships, to come back again the following summer. As one of them wrote that first summer: "There were many pleasures. I recall the first impression made by the first glimpse of rocks and pine trees and the white tents with the University pennant flying from a pole and supper laid in the Club House with bunches of water-lilies on the tables. It seemed a glimpse of fairyland."

The early summers were busy ones. The club's first caretaker, Joe Nault, built cottages by the dozen, sites were allotted and contested, surveys arranged, regattas held, and of great importance to the scientists in the group, a biological laboratory was built and equipped — with funding from the university — to study black bass and other Bay fish.

By 1903 the summer community had grown so rapidly and so many members had built their own cottages that the rustic clubhouse was no longer needed as a place of shelter. It was torn down at season's end, and its demise forever altered the focus of the Madawaska Club. The only regular gatherings from then on were the Sunday services and the yearly regattas. Today the Madawaska Club still exists as guardian of this special place where wildlife walks and quiet paddles are childhood rituals, where sketching pads and library books are more treasured than modern cottage toys, and where families gather every summer from distant corners of the world. For the descendants of the original members, now in their fourth and fifth generation, the goals have not changed. They aim to keep life simple and unhurried. Go Home must remain a place where everyone has time to sit down at the end of day and watch the setting sun.

The Madawaska Club at Go Home Bay.

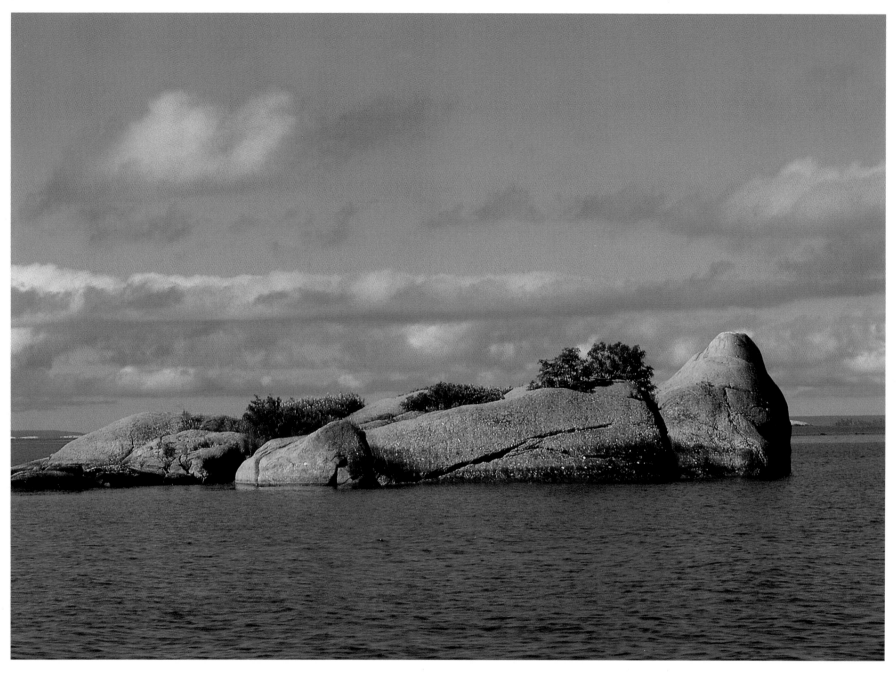

Sculptured rock formation near Go Home Bay.

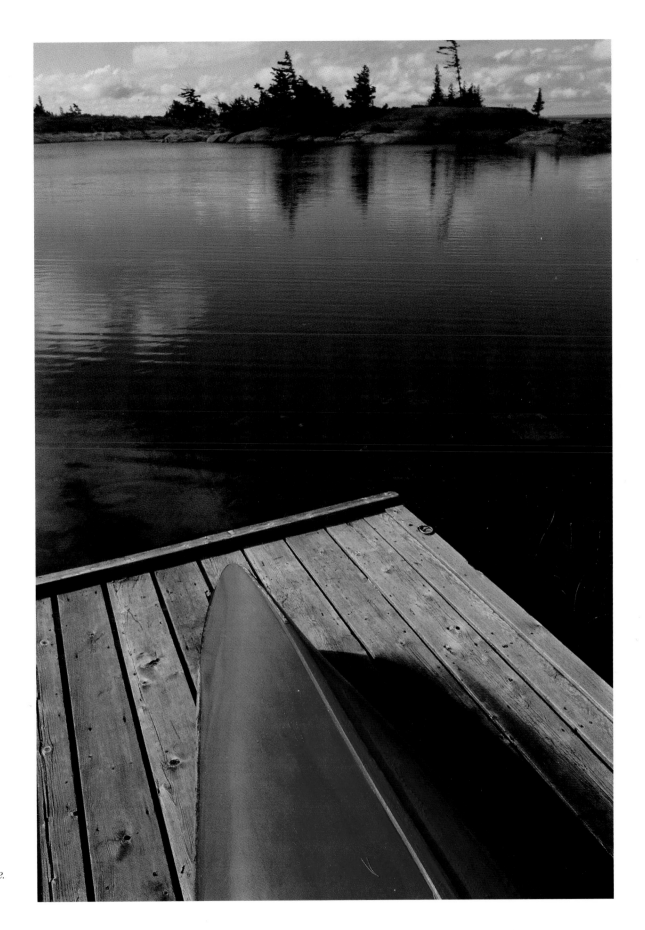

A quiet summer afternoon at the cottage.

Summer cottages hidden in the woods on the southern shore of Georgian Bay.

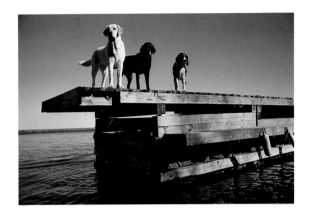

SUMMER ISLANDER

Beyond the rattling window the waves lash against the rocky shore and the howling wind contorts the pine trees into crippled shapes. Breakers crash over the shoals in sprays of white foam. The sweet-wild scent borne on the wind is like balm to summer cottagers, who breathe it in deeply as if absorbing the wilderness into their very souls.

Generations of the same family come summer after summer to these windswept islands, heedless of the weather or the distance travelled to get here. On days like this, when storms slam into the Bay, the cottager's mettle is tested. There's a certain pride in facing up to nature's awesome power, in meeting adversity to prove self reliance. Ignoring the claps of thunder, they gather around the fireplace, read beneath the coal-oil lamp or fill in a few more spaces in the jigsaw puzzle laid out on the rickety card table.

On golden summer days, Georgian Bay islanders lead a barefoot existence, paddling along narrow channels lined with scarlet cardinal flowers and plunging naked into the cool, velvety waters of the Bay. In hidden coves they picnic on sun-warmed rocks that look like melted swirls of caramel. And at day's end they putter out in slow boats to watch the setting sun.

Little has changed in the years since cottagers spent summers on these islands. Simple pastimes are still favored. Outings like shore dinners have a long history at Pointe au Baril, a cluster of islands on the eastern shore, north of Parry Sound. This account was published in 1923 in the Pointe au Baril Islanders' Association Yearbook: "The distinctive feature of life at Pointe au Baril is the shore dinner. The baskets are packed with bacon, potatoes, eggs, coffee, material for making pancakes etc., instead of the hackneyed sandwiches, cake and lemonade of ordinary picnic parties. The party then starts out in a launch towing the rowing boats and canoes to the appointed place.

"Having arrived the party scatter in the small boats to catch some bass. An hour before mealtime, with appetites keen, the party re-assembles, the bonfire is started, the potatoes put on to boil, the fish cleaned and fried with bacon, the coffee boiled, and in the shade of the pine trees and sheltered from the wind, the hungry merrymakers sit down on the sun-bleached, rain-washed rocks and eat their way through a hot dinner large enough to make three City meals.

"Then the pipes and cigarettes are got out and if it be an evening dinner, a comfortable spot on the west side of the island is sought where everyone can recline and watch the sun dip down over the horizon, while the heavens are lighted up in the crimson glow of one of those incomparable sunsets which you can see only on Georgian Bay.

"Then home to bed."

Today's version of the shore dinner is not much different. It still involves groups of friends and a flotilla of boats heading out to a remote island for a cookout. The menu hasn't changed much, though the fish are harder to catch. The pipes and cigarettes are fewer in number, but the sun-bleached, rain-washed rocks are exactly the same. And watching the sunset is still one of the joys of a warm summer evening.

Dogs on dock watch.

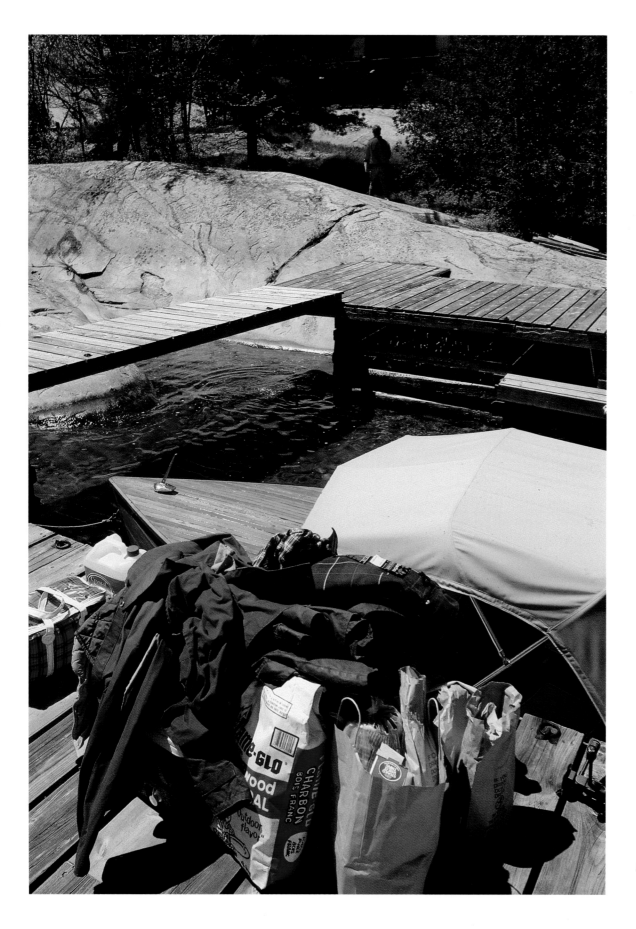

Springtime: Loaded down for the opening up.

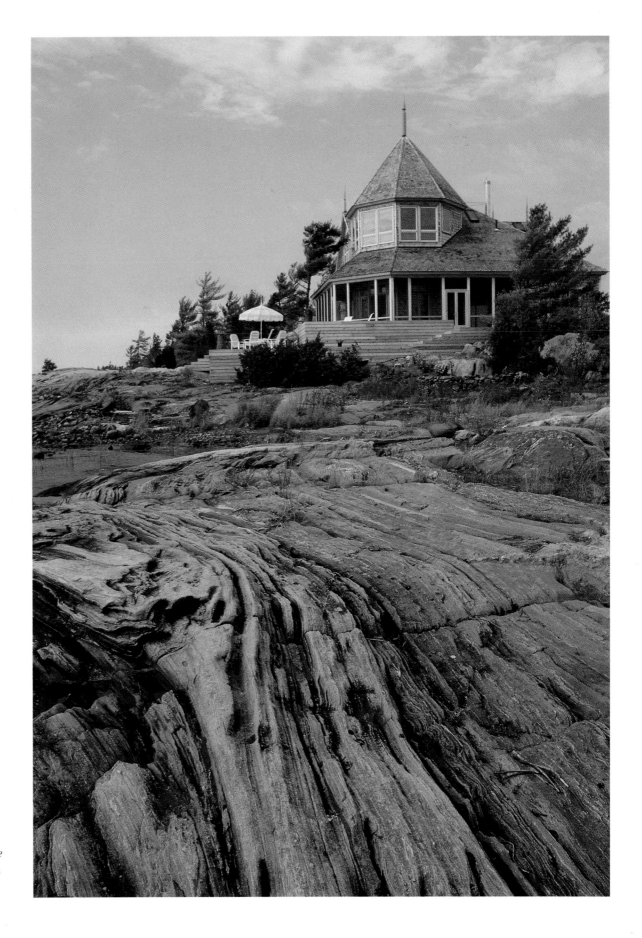

*Architect-designed summer home
near South Bay.*

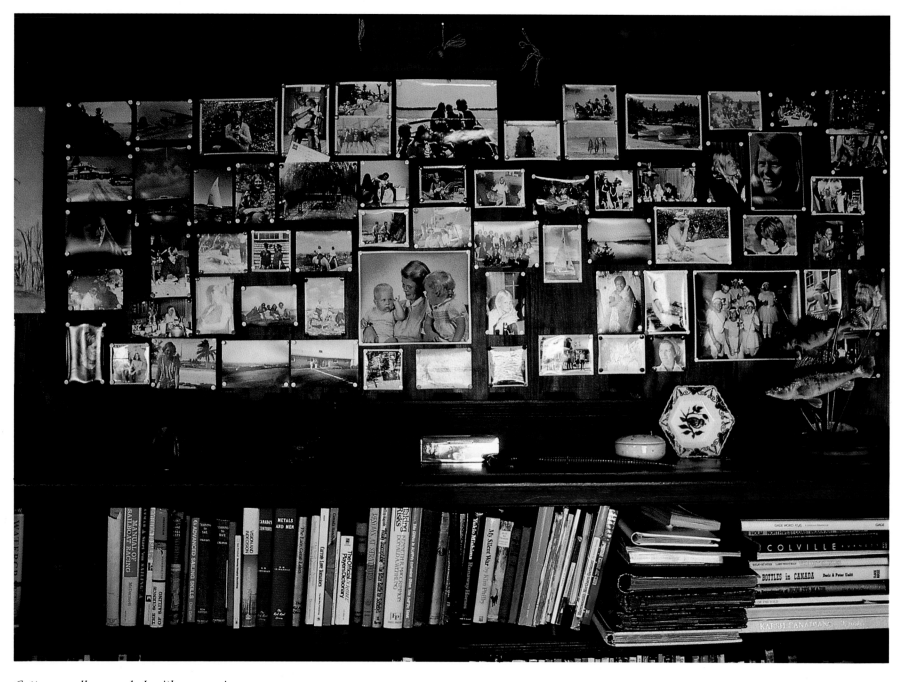

Cottage walls crowded with memories.

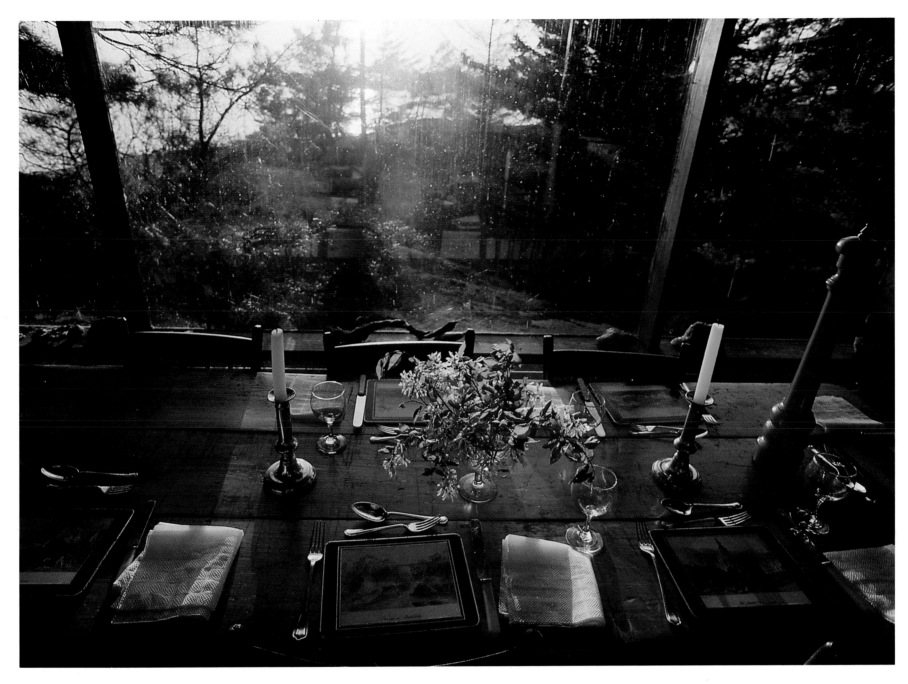

Summer dining with a view of water and pine trees.

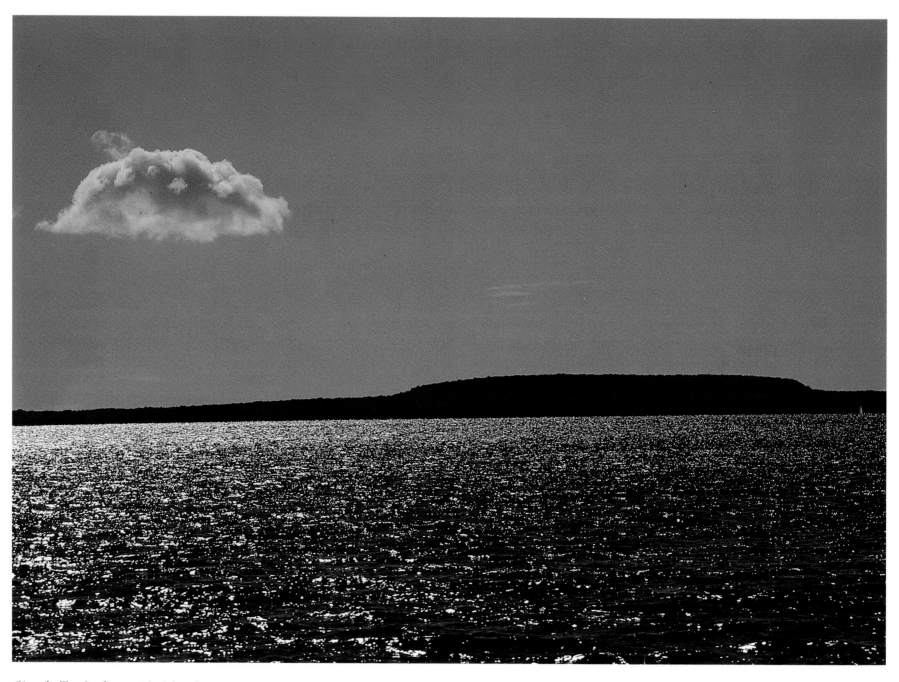

Giant's Tomb, the mystic island.

KITCHIKEWANA, THE SLEEPING GIANT

Once upon a time an Indian giant named Kitchikewana stood in Georgian Bay at the spot where Beausoleil Island now lies and he heaved great chunks of granite toward the shore. He flung them in huge handfuls, hundreds at a time, up into the sky. When they landed they became islands, and they made such great splashes that small lakes were formed far inland. After creating 30,000 islands Kitchikewana was so tired that he took two steps and lay down. Some say he's dead and that the island where he lay down is his tomb, Giant's Tomb. Others say he is merely sleeping, with the great stone hill pulled over his body like a blanket, and that when he wakes up he will start throwing rocks again. But this time he'll fill the entire Georgian Bay, from shore to shore, with mountains of granite. And on that day the world will end.

Indian legends such as this one form part of the mystique that surrounds Beausoleil Island. It is the largest in the group of islands that comprise Georgian Bay Islands National Park. This water-access park, stretched over 145 kilometres (90 mi) of coastline in the area of Honey Harbour, was formed back in 1929. At that time the government of Canada secured 29 islands in the Bay, and these were set aside for preservation. The announcement proclaimed: "These islands...are of rare beauty and of varying sizes...and it will be a consoling thought to the public to know that they are to have retained for their use some portion of Northern Ontario's earthly paradise."

Back then, Canada's national parks were few in number. The first tract of land to be designated as a protected natural resource was Alberta's Banff National Park in 1885. Over the years others were added, from coast to coast, with the goal of encouraging public understanding and appreciation of our natural heritage. Today there are 34 national parks set aside as protected land. Three of them are in Georgian Bay: the Bruce Peninsula,

Fathom Five Marine Park and the Georgian Bay Islands.

In the early days untouched land was perceived as a limitless resource. The first parks were formed by a joint venture of the government and the railroad companies. Scenic tracts of land were set aside for the visual pleasure of tourists in areas that the railroads passed through. More recently there has been a shift from protecting natural resources for commercial exploitation to protecting them for their own inherent value. Now, as unspoiled land continues to decrease, parks are established to preserve significant sections of the Canadian landscape.

Because of its location on the edge of the Canadian Shield, Georgian Bay Islands National Park (now comprising 59 islands) is unique in containing both northern and southern species of Shield plants and animals. Beausoleil Island, the largest island in the park, is a microcosm of the differences. At the north end of the island, craggy hillocks were formed when glaciers scraped and scoured the rock. At the southern end the land is more treed. Here the glaciers formed drumlins, two smooth mounds of granite, and deposited enough earthy debris around them for tall hardwood forests to grow.

Breathtaking hiking trails surround the island. Some lead through cedar swamps and orchid beds, and up drumlin ridges for a stunning view. Others meander along rocky outcrops and sandy beaches. Here and there remnants of settlers' lives can still be found, and near the visitors' centre there's a small cemetery where simple headstones mark the graves of those who once lived on Beausoleil Island.

From archeological remains we also know that Huron Indians hunted and fished here in the spring and fall. And from the rocky ridges where they tried to farm, they could look out on Giant's Tomb in the distance and check from time to time to see that Kitchikewana was still asleep.

Rock patterns.

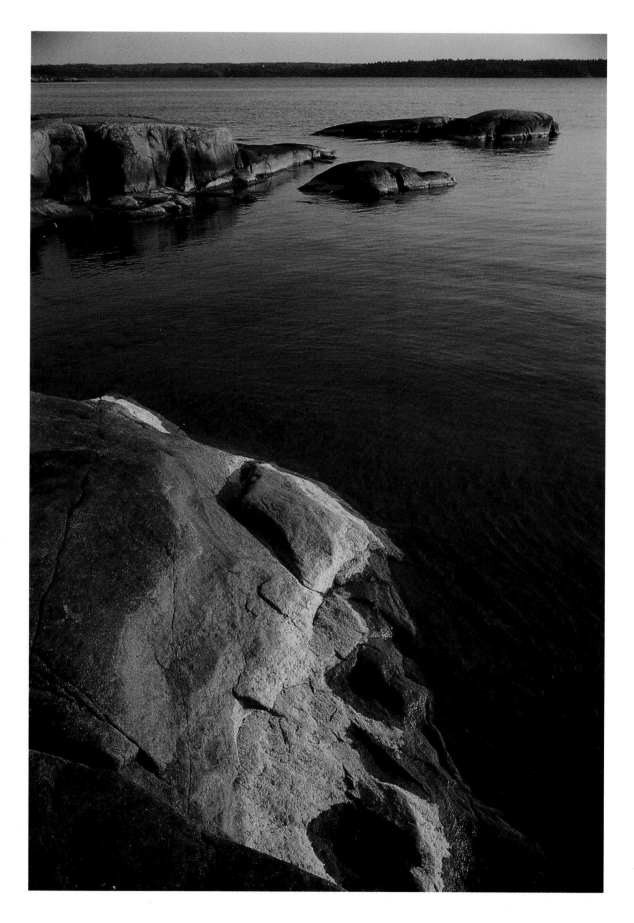

Low water at Killbear Provincial Park.

Precambrian rock in the 30,000 Islands.

Autumn splendour near Honey Harbour, gateway to the 30,000 Islands.

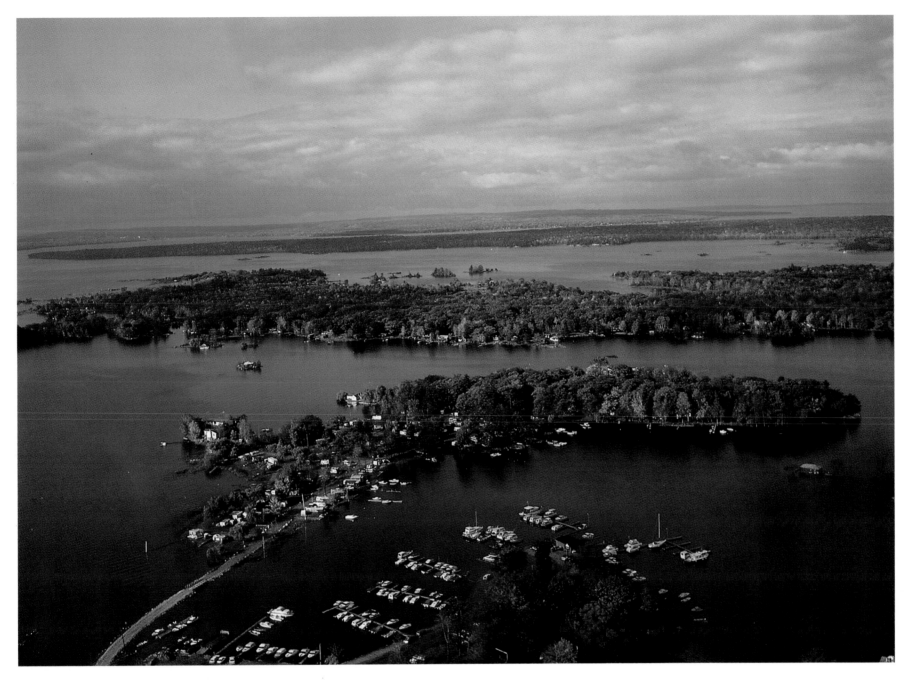

Honey Harbour in the southern pocket of Georgian Bay.

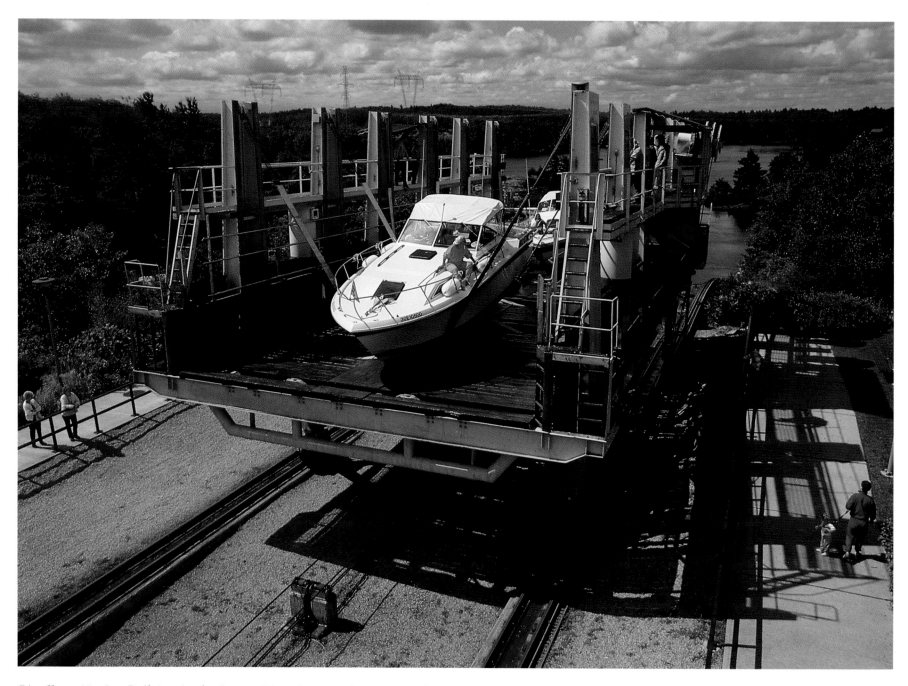

Big Chute Marine Railway in the Severn River System, the waterway linking Lake Ontario to Georgian Bay.

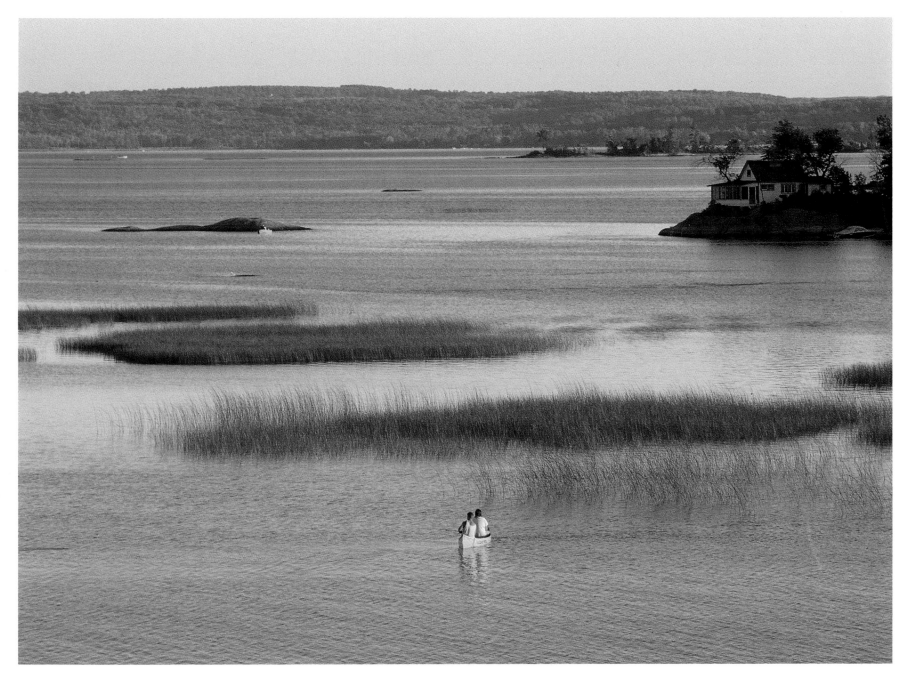

Late afternoon paddle at Port Severn.

The longhouse at Sainte Marie Among the Hurons.

SAINTE MARIE AMONG THE HURONS

Inside the longhouse it smells of wood smoke and cedar bark. It's dark except for the slashes of daylight that pierce the smoky interior through cracks in the bark roof. The narrow building stretches about twice the length of a railway car and its sides curve upward like a tunnel's. The dirt floor is scattered with deerskins, and drying corn hangs overhead on wooden poles. Gathered around the smouldering fire pit, rubbing their eyes from the acrid smoke, two young men sit with an Indian girl dressed in beaded doeskin. One of the young men is wearing heavy woollen breeches and a leather vest, the other is in the long black robe of a Jesuit priest. As the girl scrapes kernels of corn into a wooden bowl she turns to the young men and asks, "So when do you guys have to be back at university?"

It's nearly the end of summer and the costumed staff at Sainte Marie Among the Hurons have started to think of other things. Soon they will be gone, as will the tourists who flock here every summer to see what life was like back in 1639 in Ontario's first European community. This palisaded village set on the marshy banks of the Wye River represents a fascinating chapter in the history of Georgian Bay. It was here that a small group of Jesuit missionaries from Québec attempted to convert 25,000 Huron Indians to Christianity.

Like many early Canadian stories, this one involves Samuel de Champlain, who visited the region in 1615, seven years after he founded Québec. Travelling with two other Frenchmen and ten Indians, he paddled from Québec by canoe along the Ottawa and Mattawa rivers to Lake Nipissing, then down the French River to Georgian Bay. He reached Penetanguishene, on the southern shore of the Bay, a month later.

Arriving in Huron territory, Champlain was impressed by these healthy, handsome people and admired their lands, which were lush with corn, squash and sunflowers. But he was concerned that "so many poor creatures should live and die without any knowledge of God...." It was after he wrote this report that the French crown decided to initiate a policy to save the souls of the Hurons. This policy would lead to the building of Sainte Marie Among the Hurons and ultimately to the destruction of almost the entire Huron tribe.

Following Champlain's visit several attempts were made to establish missionaries among the Hurons, but none was successful. Father Jean de Brébeuf was made superior of the Huron missions in 1634 and he enjoyed limited success. But his missions were promising enough that his successor, Father Jerome Lalemant, decided to build a Jesuit headquarters on the banks of the Wye River in 1639. They called it Sainte-Marie-aux-pays-des-Hurons and it was to be a comforting refuge for the priests who were tired of struggling in desolate wilderness outposts.

At its peak, the mission had 20 buildings and housed hundreds of converted Hurons as well as one-fifth of the entire European population of New France. It was a bustling place. Smoky longhouses were crammed with extended families, craftsmen whittled logs into furniture, the cookhouse was warm with the scent of baking cornbread, barns were filled with cattle and pigs brought by canoe from Québec, and chapel bells rang throughout the compound from dawn until dusk.

But the mission was short-lived. Many of the Hurons had already died during a devastating smallpox epidemic. Then, in 1649, the Hurons' long-time enemy, the Iroquois, set out to attack the palisaded village. They tortured and killed Fathers Brébeuf and Lalemant at another village before storming toward Sainte Marie armed with muskets. Rather than see their mission destroyed by the enemy, the remaining Jesuit fathers

Sainte Marie Among the Hurons on the Wye River.

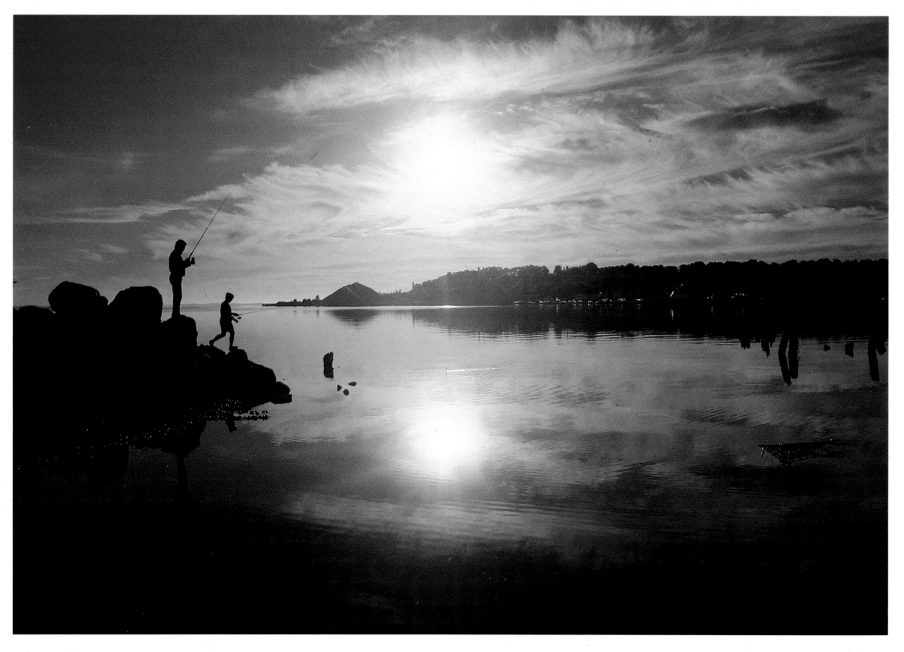

Midland Bay.

set the place on fire. As one of them wrote: "...in a single day, and almost in a moment, we saw consumed our work of nearly ten years...our home is now laid waste." Also laid waste was an entire community of Huron Indians. A few survivors fled to Christian Island but had to leave there the following spring because of food shortages. In the end, a few priests and about 300 Hurons returned to Québec. Today, the last of the Hurons live at Loretteville, just north of Québec City.

In 1967 Sainte Marie was reconstructed by the Ontario government as a heritage project for Canada's centennial year.

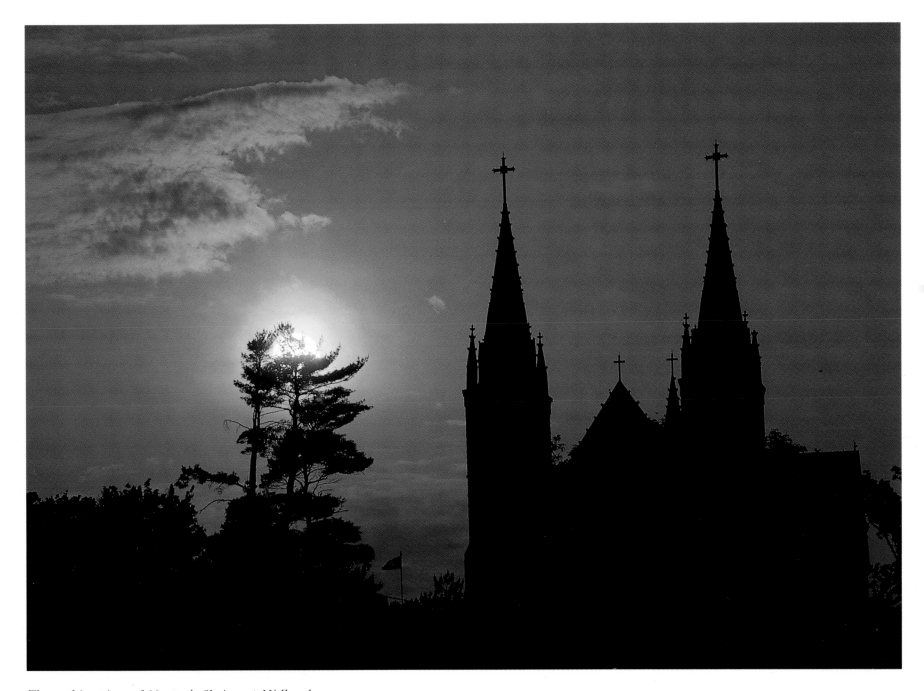

The gothic spires of Martyr's Shrine at Midland.

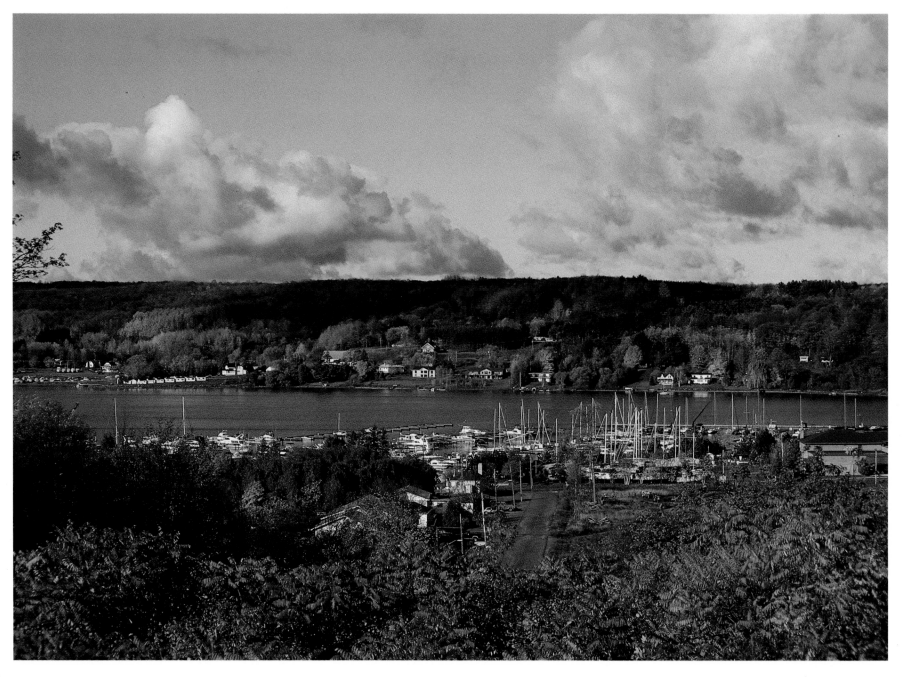

View across Penetang Bay.

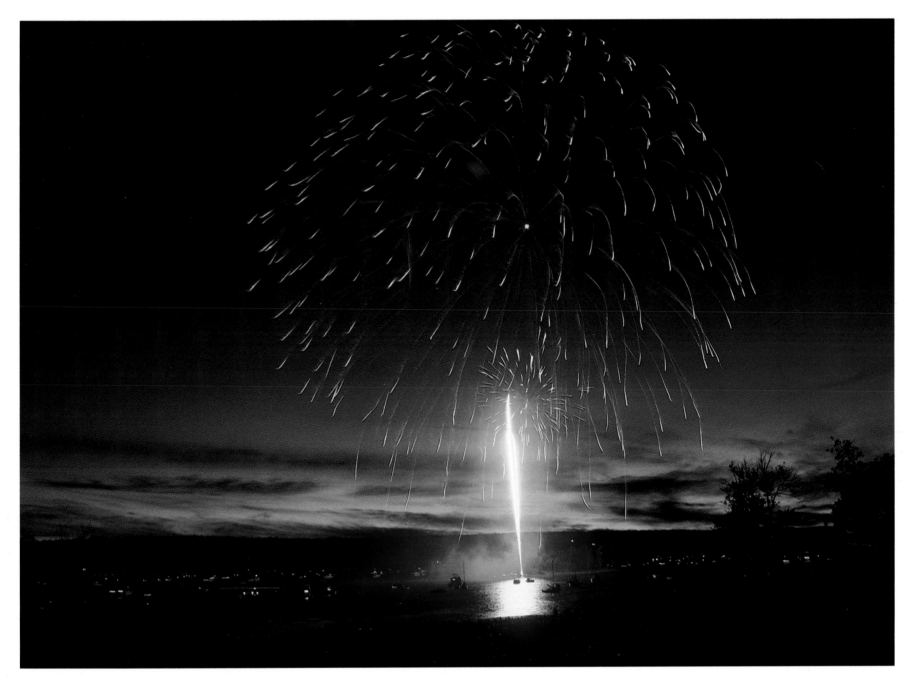

Canada Day celebrations at Penetang harbour.

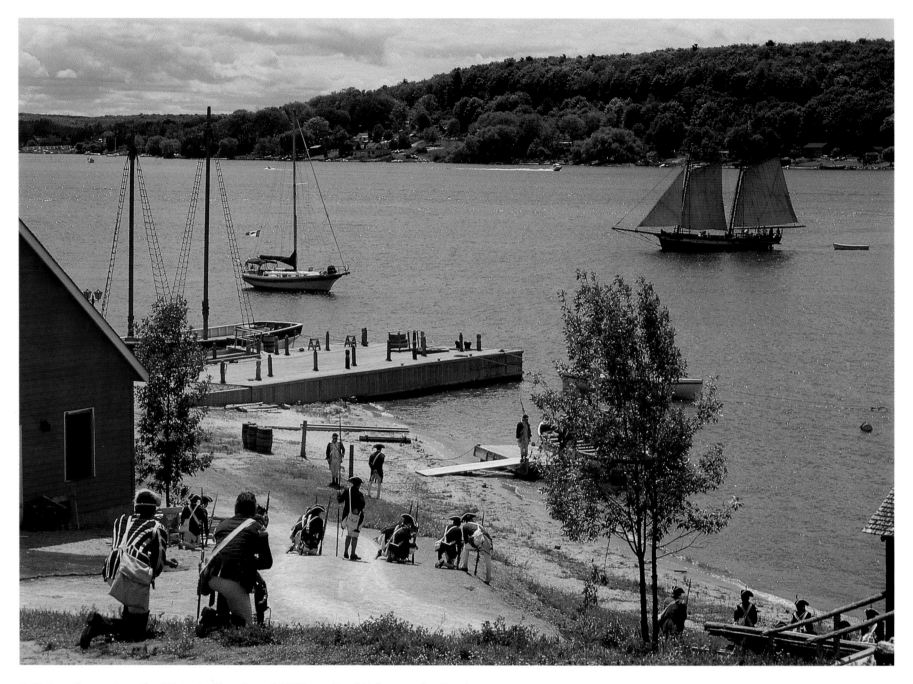

Reliving the past at the Historic Naval and Military Establishments in Penetang.

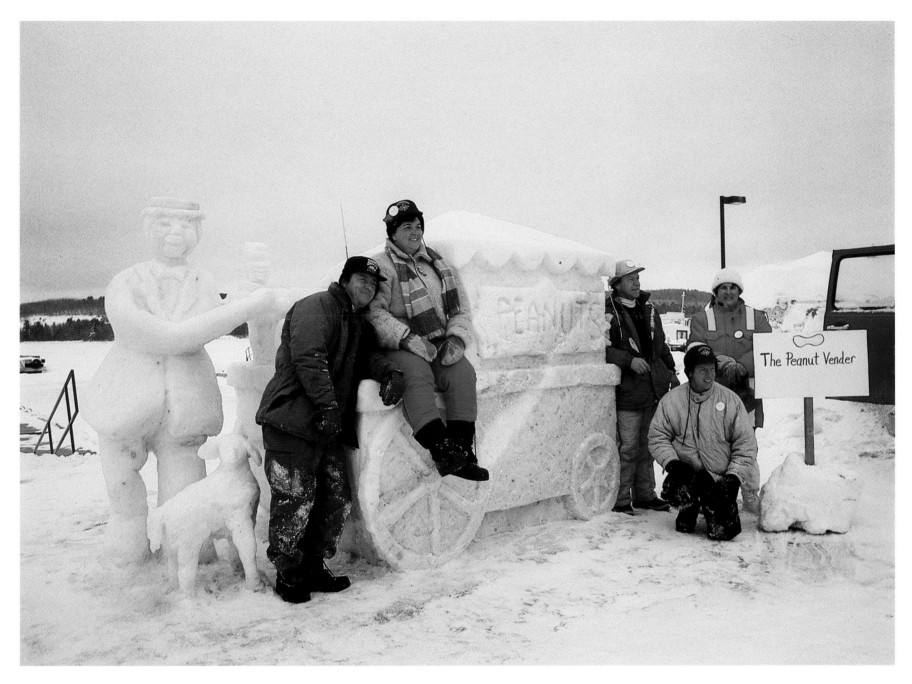

Ice sculpture at "Winterama," Ontario's oldest continuous winter carnival, in Penetanguishene.

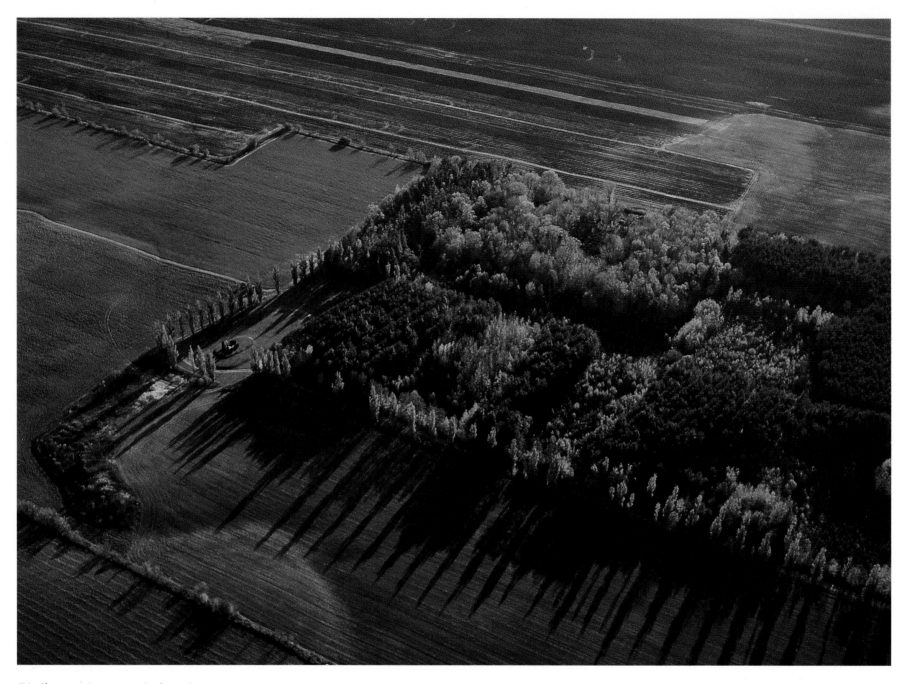

Bird's-eye view near Lafontaine.

Site of the first mass in Upper Canada, near Lafontaine.

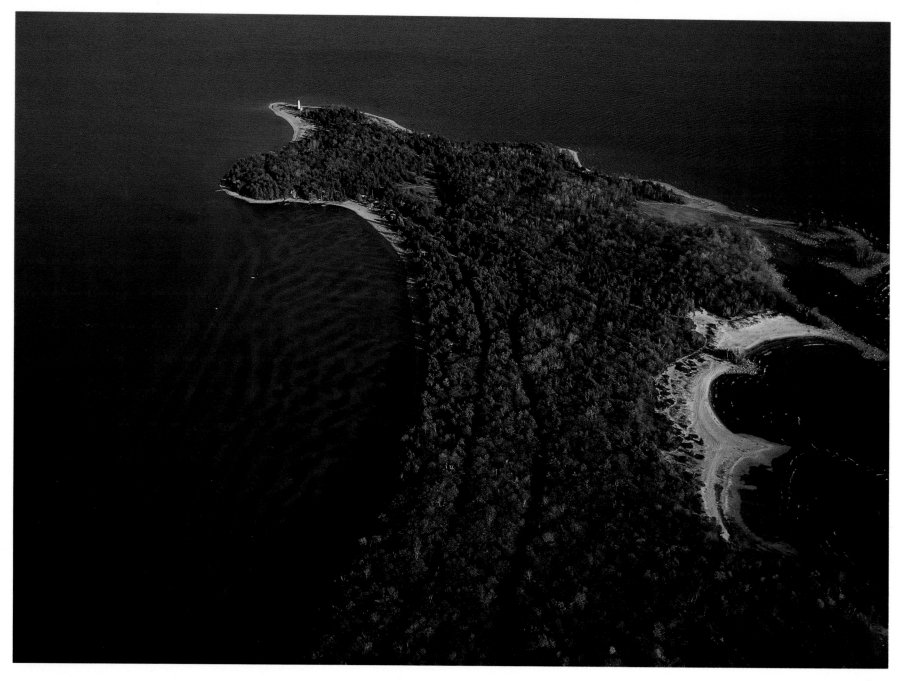

Christian Island.

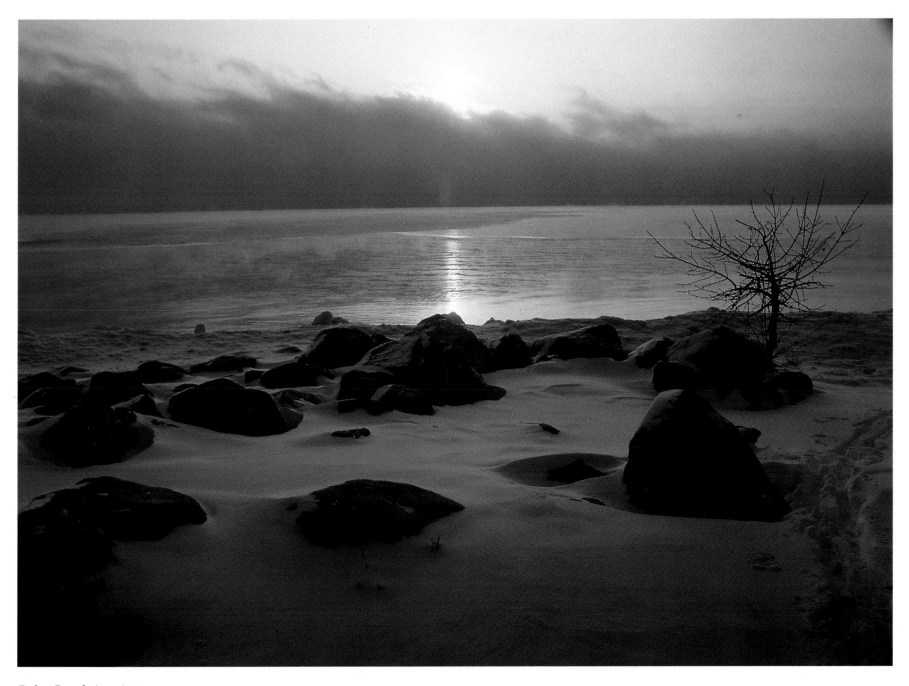

Balm Beach in winter.

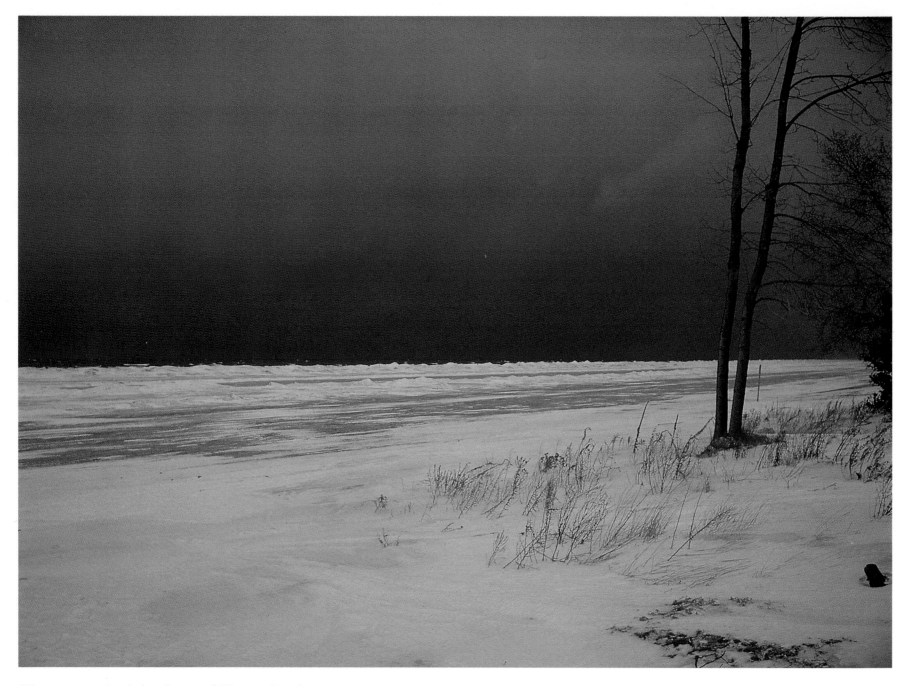

Winter storm clouds head toward Wasaga Beach.

BIG DOG, LITTLE DOG, SHEBESHEKONG, CAWAJA NAMING NAMES ON GEORGIAN BAY

The longest freshwater beach in the world is Wasaga Beach, yet its name is not Long Beach or Vast Beach or Stretch Forever Beach, it's Wasaga, a shortened version of Nottawasaga, which has nothing to do with length but is an Algonquin name for "outburst of the Iroquois." Then there's the string of beaches that curve up the shore from Wasaga — Woodland, Deanlea, Ossossane, Cawaja. Cawaja? Another name of Indian origin? No. It's an anagram derived from the initials of the men who founded it. Moving around the corner there's Thunder Beach, named for the booming noise created by the echo off the two headlands during a storm.

It's believed that Go Home Bay was named by hunters and lumbermen because it was the access point to the Muskoka region. From here they were able to leave Georgian Bay and return to civilization. Hence they named it Go Home Bay. Further north it was a group of French fur traders who named Pointe au Baril. While travelling by canoe they found a *baril* (French for small keg) floating in the bay and hung it on a pole to mark the channel's entrance. From then on, it was known to passing canoeists as Pointe au Baril. And the French name Sans Souci was chosen because "once you were settled in for the summer (assuming you survived the long and arduous journey from civilization via train and boat) life truly was "without worry."

Back in the days when explorers and surveyors were able to choose names, they named places after people. When Captain Henry Bayfield surveyed Georgian Bay in the 1820s, he named a lot of places. After discovering a lovely landlocked sound on the north coast, he named it Parry Sound after his hero, Arctic explorer Sir William Edward Parry. Bayfield named Byng Inlet

for an admiral of the British navy, John Byng. And when he came to the beautiful area north of the Bad River, he honoured his friend and chief assistant Midshipman Philip Edward Collins by naming the island Philip Edward and the inlet Collins. But Bayfield was less enchanted with the Bustard Islands. He named them for the large, long-necked and rather homely game birds found on the deserts and plains of Africa, Europe and Asia.

Some of the area's most beautiful names have Indian origins. Shawanaga is Ojibwa for "long bay or strait" and Penetanguishene means "land of the rolling white sand." Shebeshekong Bay means the "place of leaves" and Waubuno Channel is named for the "soft west wind." The island of Minnicognashene is a mouthful of a word which translates as "point of many blueberries."

Dogs play a part in the name game too. There's Big Dog and Little Dog channels, which were, according to Indian legend, named after a young maiden's two pet dogs that were killed by falling rocks. Even more outlandish are the three townships in Simcoe County — Tiny, Tay and Flo — named for three lap dogs belonging to Lady Simcoe, wife of the English governor.

Up in the Bruce Peninsula, Lion's Head is so named because of the profile of a lion's head on the magnificent white cliffs located there. And further north the town of Tobermory was named by Scottish immigrants homesick for a town on the Isle of Mull. The landscapes around the two towns look remarkably alike. Wiarton honours the birthplace of Sir Edmund Walker Head, Governor General of Canada at the time the Bruce was surveyed. Head was born at Wiarton Place in Kent, England. Cabot Head was named in honour of John Cabot, the discoverer of Canada.

The sands of time at Cawaja Beach.

A sweet tale is told about the origin of Honey Harbour's name. Once upon a time a beekeeper wanted to keep his different strains of imported queen bees segregated from one another, so he put them on different islands in the southern part of Georgian Bay. The bees did not store all their honey in the appointed hives, some of it was deposited in hollow logs in the bush. When people discovered this, they came by boat to collect the honey and from that time on the harbour's name "stuck."

Georgian Bay itself had a variety of names over the years, but its final moniker came from Captain Bayfield, who in 1820 named it for the newly crowned King of England, George IV.

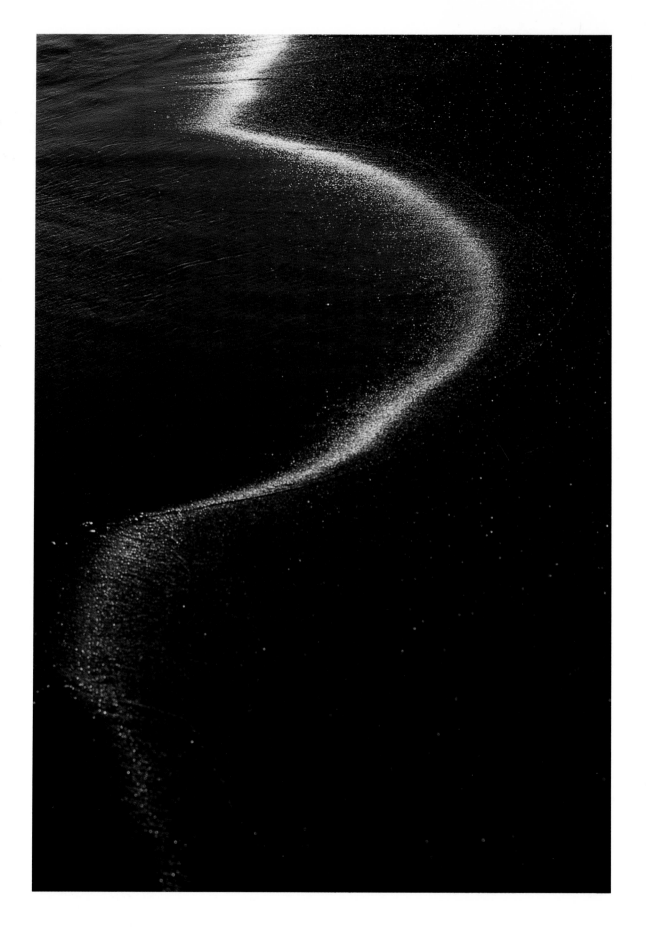

Golden light along the beach.

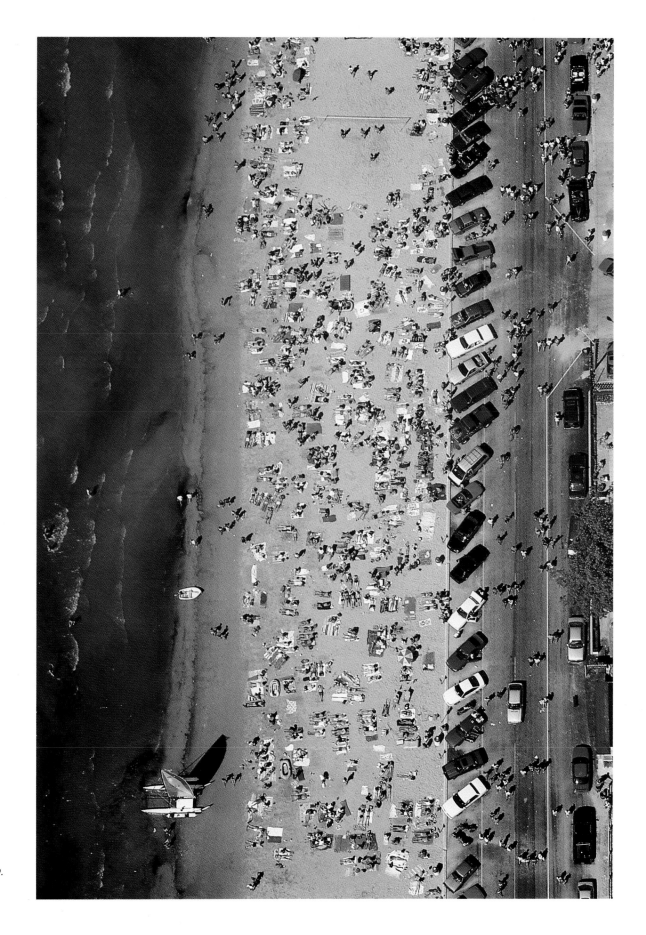

A midsummer's day at Wasaga Beach.

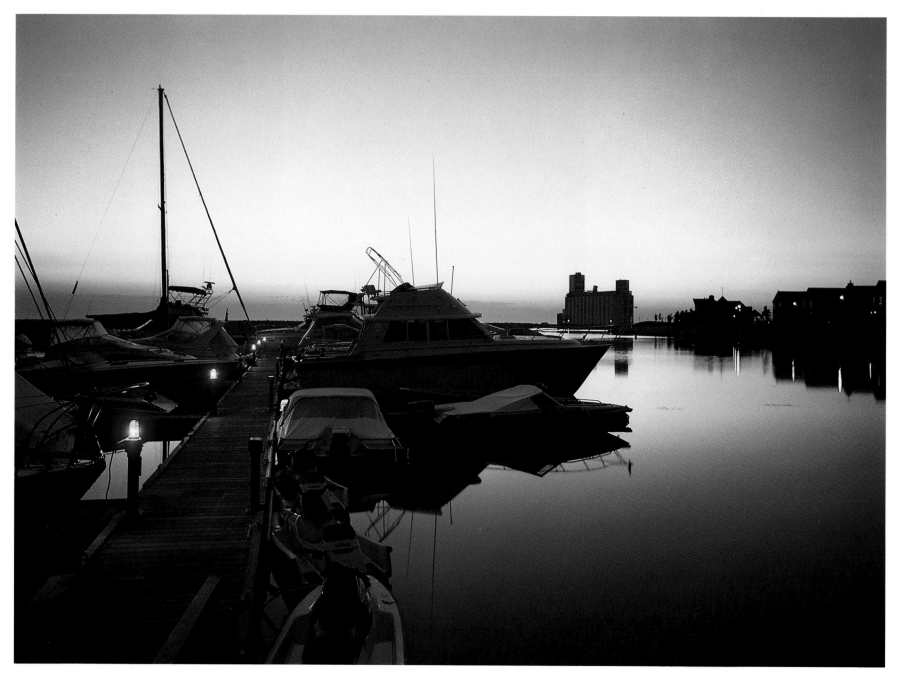

Collingwood at dusk.

TORNAVEEN

At the corner of Oak and Third Street in Collingwood stands a colossal red-brick mansion, a symbol of Victorian opulence in a neighbourhood of modest homes. The house, the tallest and grandest in town, has a past full of intriguing ghosts, but today it's home to 24 lively youngsters who dream of becoming Olympic skiers. The interior of the 14-bedroom mansion is so lavish that, in 1891, just after it was built, the local press claimed it was "good enough for a prince." Today, in the high-ceilinged bedrooms with their bevelled-glass windows, kids sprawl across beds, writing essays and doing homework. Ski posters and school timetables are plastered above the wainscotting. Downstairs, in the parlour, a group sits watching videos of their performance on the ski hills, oblivious to the ornate ceiling medallions and richly panelled mahogany walls.

Since 1987 the National Ski Academy has run an educational training facility in this house, a place for young athletes to train and be educated. With benevolent private donations, the house was bought and refurbished as a facility to provide these young people with a program of academics and athletics. "In the past, young ski racers had to give up their education in order to meet the demands of the training program," says Pippa Blake, the enthusiastic manager of the National Ski Academy. "Now they go to school at Collingwood Collegiate half the day and train on the ski hills the other half. It's an ideal arrangement. We have great hopes for these young skiers."

The groomed ski hills that spill down the sides of the Niagara Escarpment between Devil's Glen and Georgian Peaks didn't even exist when "Tornaveen" was built. The town of Collingwood, nestled on the southern shore of Georgian Bay, was experiencing considerable prosperity, and its position as a strategic port facility on the Great Lakes led many to believe that it would become the "Chicago of the North." Inspired by this optimistic view, many of the town's leading businessmen built extravagant homes with towers, gables and sprawling verandas. But none was as conspicious as Tornaveen.

In 1891 Frank Telfer was the 38-year-old mayor of Collingwood. His wealth came from the family business, Telfer Brothers, a wholesale biscuit manufacturing company. Determined to live in a home that reflected his stature in the community, Telfer bought five lots and hired the town's leading architect, Fred Hodgson, to design a home with 10,000 square feet (929 sq m) of living space. He apparently wanted it to be larger and grander than his brother Frank's house, "Armadale," which was right across the street.

For a while in the early 1900s, the homes of the two Telfer brothers provided the hub for society activities in Collingwood. Elaborate parties were held in the richly decorated drawing rooms, and when visiting royalty came to town, they were feted in the gardens of Armadale and Tornaveen. But these heady days came to an abrupt end in 1924 when the Bank of Toronto called its loan and the Telfer brothers lost the family business. Soon after, Frank Telfer sold Tornaveen.

The next group to occupy this enormous house were children whose parents were Canadian missionaries working in remote parts of the world. The Gowans' Home for Missionaries'

Tornaveen, Collingwood.

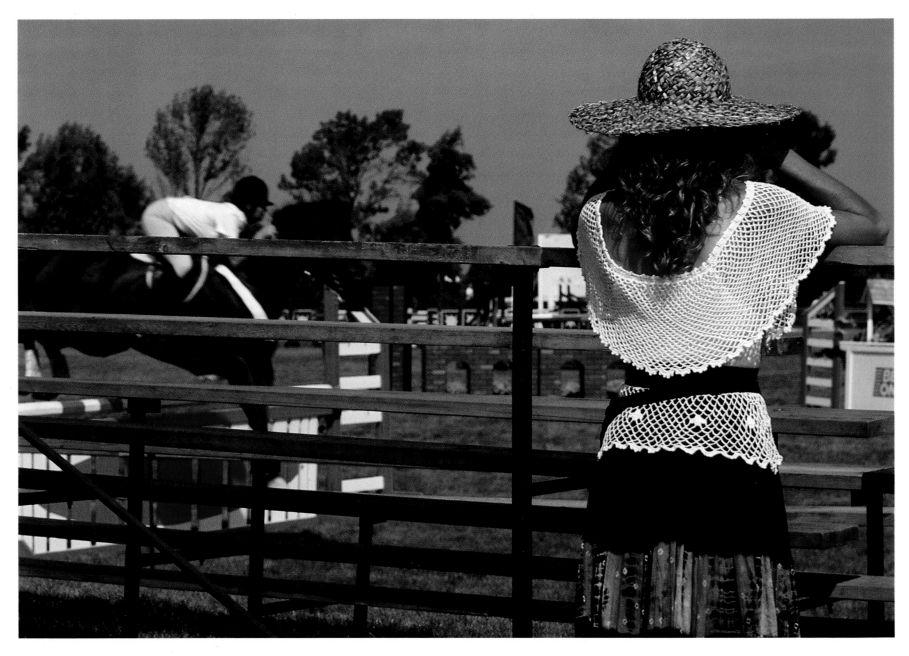

Collingwood Horse Show.

Children was an organization that provided a "stable Christian home" for the offspring of missionaries posted overseas. Until the mid-1960s both Armadale and Tornaveen were filled with these children. But missionaries began to take their children with them to foreign postings and the need for such places came to an end. Tornaveen sat empty and derelict for years.

Today the house is once again filled with youngsters. Down in the basement, in the room that was once a coal cellar, students of the National Ski Academy lift weights and do workouts with their fitness coach. And upstairs in the attic, where servants once lived, the students work at wooden desks in a large study hall. Tornaveen is still a splendid house, with its stained-glass windows and wide sweeping staircase. But instead of brocade sofas and Oriental carpets, the mansion is currently furnished with cast-offs, donations from the Academy's many supporters. Collingwood has also changed since the house was built. No longer a prospering port, the town's economy is now based on tourism and skiing. And instead of resounding with the chatter of society gatherings, Tornaveen is filled with the liveliness and energy of Canada's future Olympic skiers.

Abandoned shipyard buildings in Collingwood harbour.

The Scenic Caves and Caverns off Highway 26, part of the Niagara Escarpment.

Farmland in Nottawasaga County.

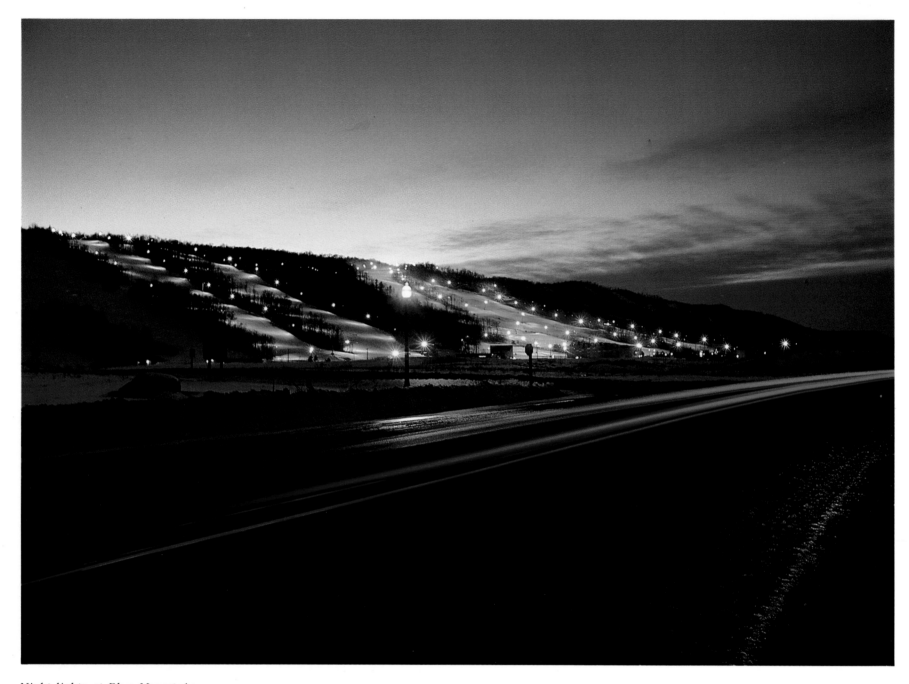

Night lights at Blue Mountain.

BLUE MOUNTAIN

It's four o'clock on a winter afternoon. Dark snow clouds scud across the leaden sky as brightly clad skiers come swooshing to a stop at the bottom of Blue Mountain, Ontario's largest ski resort. The day is damp and grey, but the hills are alive with the sound of Muzak blaring from an overhead loudspeaker. The group gathered at the base are complaining about mushy snow and bare spots. "We need more snow," they agree, eyeing hopefully the heavy clouds. Deciding on one more run, they glide off to the chairlift, promising to meet at Jozo's later for a beer. To this young group, Jozo's is the name of a bar in the hotel at the base of Blue Mountain, but at least one Blue Mountain veteran remembers the person.

Jozo Weider. Back in the late fifties you couldn't go to Collingwood to ski and not know about Jozo. He was from Czechoslovakia and had come to Blue Mountain to be an instructor and sports director in 1941, when the ski area was first being carved out of the face of the Niagara Escarpment. By the 1950s he was well established as "Mr. Blue Mountain," the ubiquitous man in charge. He yodelled as he skied down the hill. He wore Alpine-looking ski outfits. He ladled out *gluhwein* and hot chili for the skiers at the bottom. And he played the accordion in the Ski Barn at night. Jozo was about the most exotic European this unworldly teenager from Toronto had ever encountered.

It was in the Ski Barn that she first saw him. Jozo had bought the old barn that had once been part of an apple farm, and he had turned it into a lodge at the base of the mountain. The barn, decorated like a Swiss chalet, was where skiers gathered around long wooden tables. Always crowded, it smelled of steaming weiners and wood smoke. With its sloping wooden floor, weathered beams and its wagon-wheel lantern hanging overhead, it certainly seemed European to her. The first time she saw Jozo he was over in a corner of the Barn leading a singsong. The skiers, some of them leaning over the upstairs railing, sang out exuberantly, "Oh, I love to go a wandering, along the mountain paths. . . ."

The whole place was new and foreign to her. She'd never skied before, but her friend had convinced her that he was an expert on the slopes and would be able to teach her. He talked glibly of jump turns and *gelandesprungs* and other alien-sounding activities. But she was undaunted, she wanted to be part of the crowd that headed up to Collingwood every winter weekend. She had hoped to buy new ski equipment but had ended up instead with her father's old wooden skis, circa 1942, and his lace-up leather boots, which were several sizes too big. She did think her ski pants were stylish though. They were made of stiff, stretchy material that fit tighter than a girdle. She had borrowed them from a thinner friend.

The hill out behind the Ski Barn had a rope tow which her friend assured her was easy to master. To her the hill looked steep and hazardous, but apparently it was called a "sissy schuss" by those in the know. She tried to appear confident as she clomped toward the tow with all this foreign gear attached to the bottoms of her feet. Watching the others grab onto the rope and head up the hill with knees bent and skis pointed forward in their tracks, it looked fairly easy. But then it was her turn. Somehow the rope seemed as slippery as an eel, and within seconds her skis were pointed in opposite directions. Before she knew what had happened she had tumbled into a heap of tangled skis and twisted limbs. Her friend was nowhere in sight.

The Blue Mountains viewed from across Nottawasaga Bay.

Summer storm over Nottawasaga Bay.

By comparison, the skiers at Blue Mountain today all look confident and capable. The old Barn hill is now the back yard to condominiums, and rope tows are a thing of the past. Instead there are detachable quad chairlifts with names like Silver Bullet that whisk skiers to the top of 30 different trails spread out along the Escarpment. And instead of the rustic old Ski Barn, there's the Blue Mountain Inn, a sprawling five-star resort built in 1981, ten years after Jozo Weider's tragic fatal car accident.

Today's Blue Mountain bears little resemblance to the Blue Mountain she remembers from 1959. But it is probably the Blue Mountain that Jozo would have wanted it to become, a successful all-season resort. His son George Weider and other members of family still run the operation. And Jozo's memory lives on in road names and après-ski bars and in myriad colourful Blue Mountain memories.

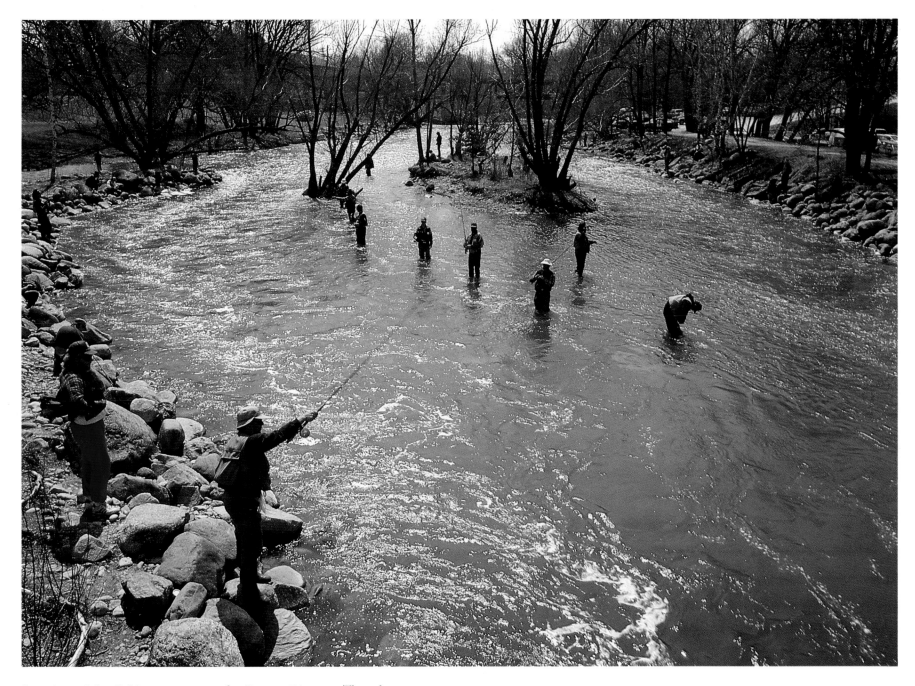

Opening of the fishing season on the Beaver River at Thornbury.

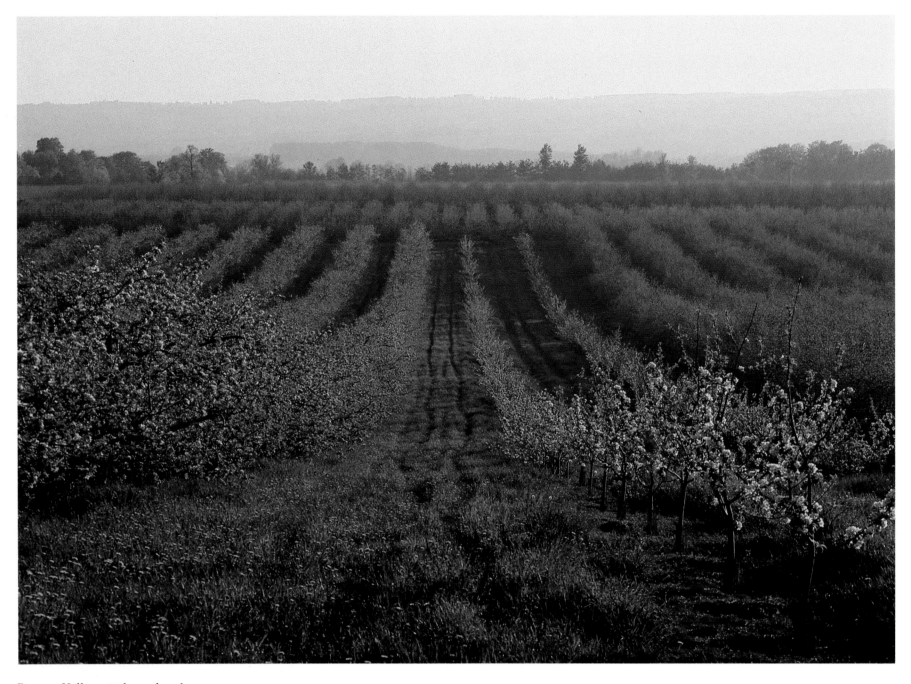

Beaver Valley apple orchards.

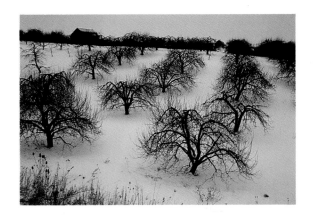

APPLE COUNTRY

From a rocky ridge part way up the Niagara Escarpment, the springtime view of the Beaver Valley is as pretty as a pastel patchwork quilt. Squares of white-blossomed apple trees line up next to newly green farm fields, and all around is the aquamarine border of Georgian Bay. This is apple country. Towns like Thornbury, Clarksburg and Meaford sit in the midst of a thriving apple-growing industry. And if you miss the apple orchards, you can't miss the Meaford information booth. It's a huge red apple right on Main Street.

The region was considered ripe for fruit farming as early as 1835, when a young man from Mono Township canoed up to Nottawasaga Bay looking for land. The area had been surveyed in 1832 and plots made available for settlers. After canoeing along the shore, James Carson wrote in his diary: ". . . level land for farming, which with its shore front and sheltered by the hills behind, would be safe from late and early frosts, and would be an ideal spot for fruit growing."

Carson's predictions were accurate. Over the next few years apple orchards were planted all over the flat fertile crescent of land tucked between the Escarpment cliffs and the blue-green waters of the Bay. It turned out to be ideal fruit-growing country. The valley on either side of the Beaver River protects the land from the most severe weather, and the vast expanse of water on Georgian Bay moderates the cold winters.

When the settlers first planted fruit trees for their own food, they found the trees grew amazingly well. A combination of sandy loam and silty clay left by the glaciers provided ideal growing conditions. Soon apple orchards were established in neat plots throughout the township, and by the 1880s some were as large as 4 hectares (10 acres).

In those days apples were packed into 1.2-metre-tall (4 ft) wooden barrels. Several cooperages in the area kept busy supplying the apple farmers with barrels. In the days before rail service, apples were loaded by the barrel onto steamers in Thornbury harbour for transport to the north country. Many varieties were grown in the early years — Russets, Rhode Island/Greenings, Baldwins and others. By 1961 twenty-two different varieties of apples were grown in commercial quantity in Grey County. As the years went by, farmers tended to specialize, increasing their precentages of Spy, McIntosh and Delicious.

Soon after the turn of the century a young farmer named William L. "Billie" Hamilton began to grow apples on his family farm in Nottawasaga Township, just 2.4 kilometres (1.5 mi) from Collingwood. He increased an old .8-hectare (2 acre) apple orchard to 16 hectares (40 acres) and concentrated on growing McIntosh and Northern Spies. His orchards thrived and in 1912 his apples won their first prize, the Canadian Sweepstake at the Horticultural Exhibit in Toronto. From then on, Hamilton won trophy after trophy, everywhere from New York to London, England. His apple prizes became so legendary that he made headlines in the Toronto *Globe and Mail* on February 17, 1947, when he was hailed as the "apple king of the world."

The fame of the apples grown on this Georgian Bay crescent spread far and wide, and today apple-growing remains a thriving industry. Apples from the region are still winning prizes. But back in the late forties Billie Hamilton's prize-winning days at the Royal Winter Fair in Toronto finally came to an end when he was barred from entering the Sweepstakes. The officials in charge claimed that they wanted to give other apple-growing exhibitors a chance to win. The Apple King of Nottawasaga was unceremoniously deposed.

Apple farm near Thornbury.

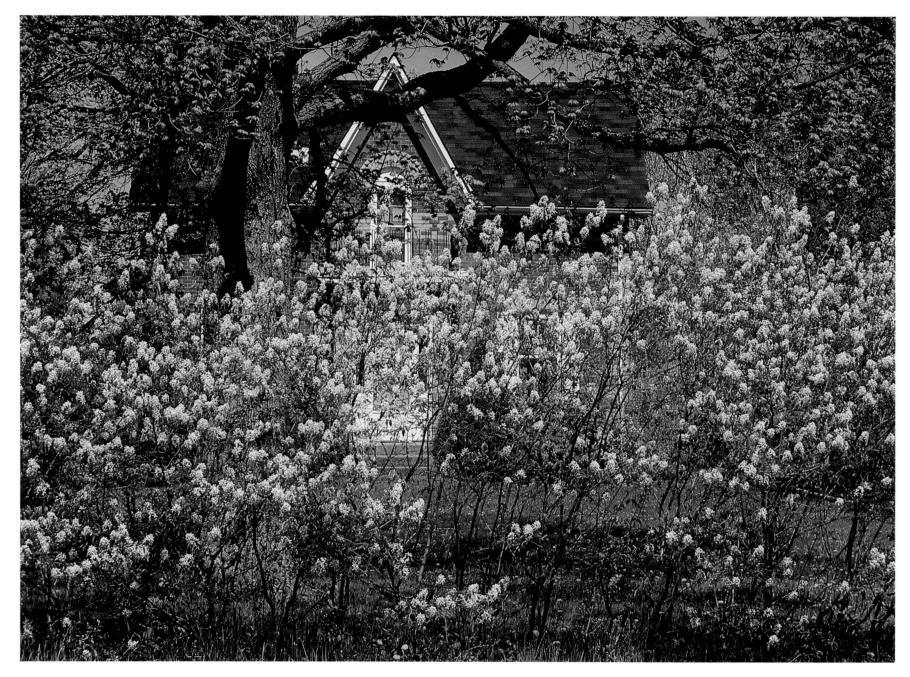

Apple blossom time at Thornbury.

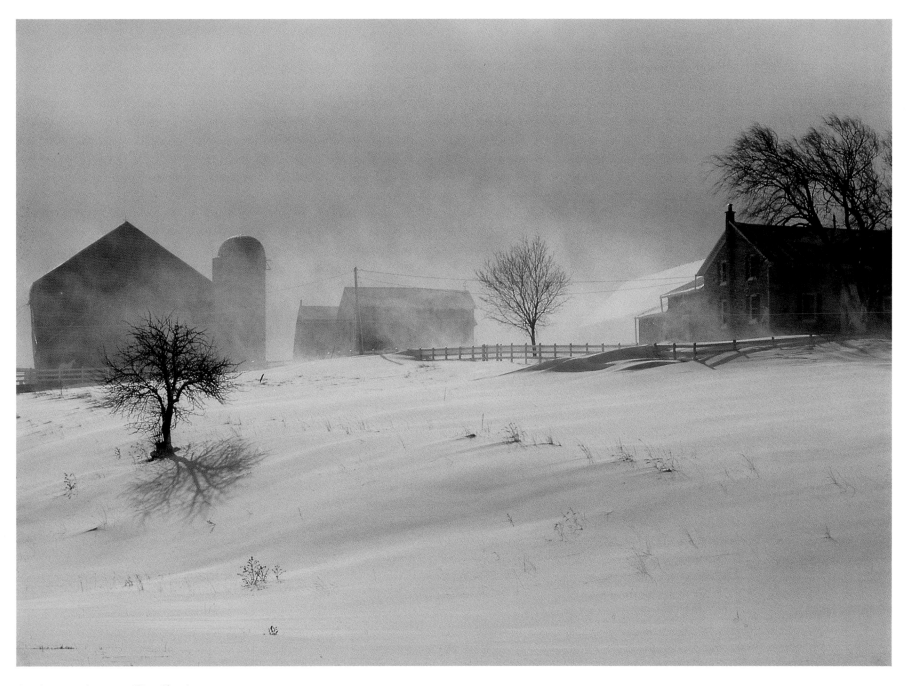

A winter gale near Woodford.

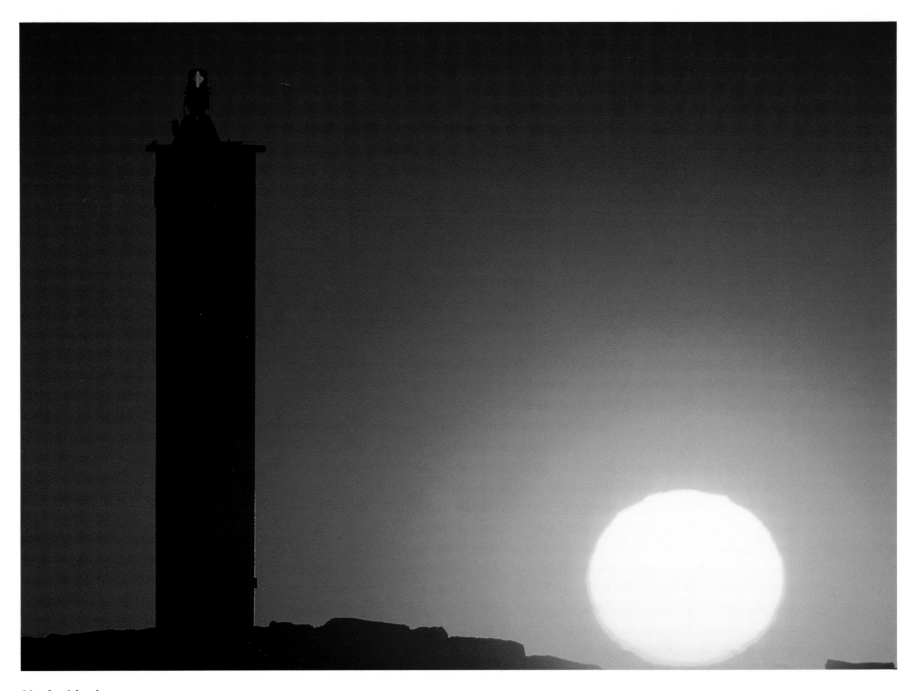

Meaford harbour.

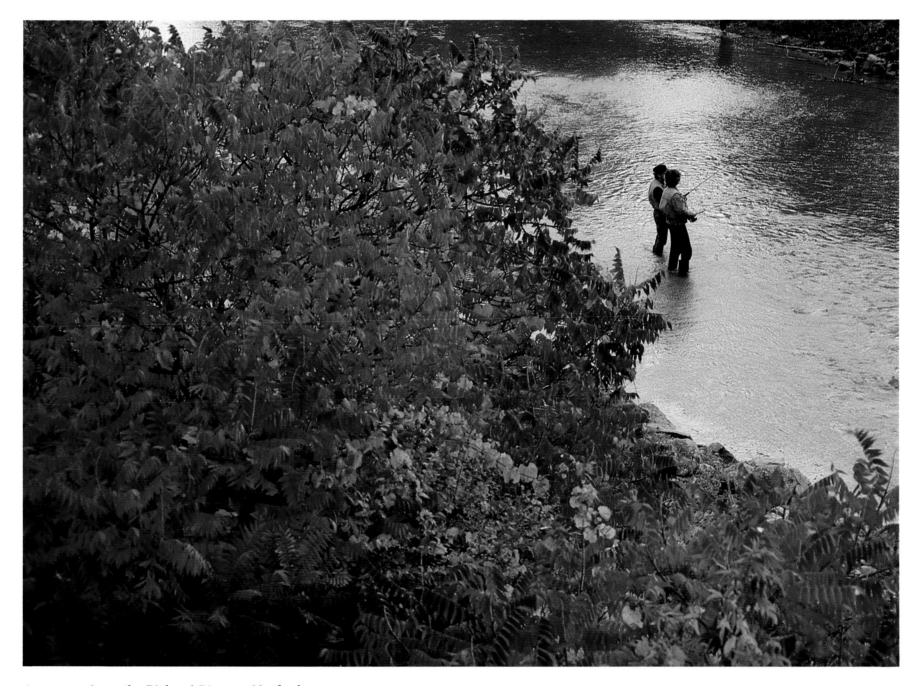

Autumn reds on the Bighead River at Meaford.

They're off — at the Georgian Bay Poker Run off Owen Sound.

Winter at Owen Sound.

Indian Falls Conservation Area at Owen Sound.

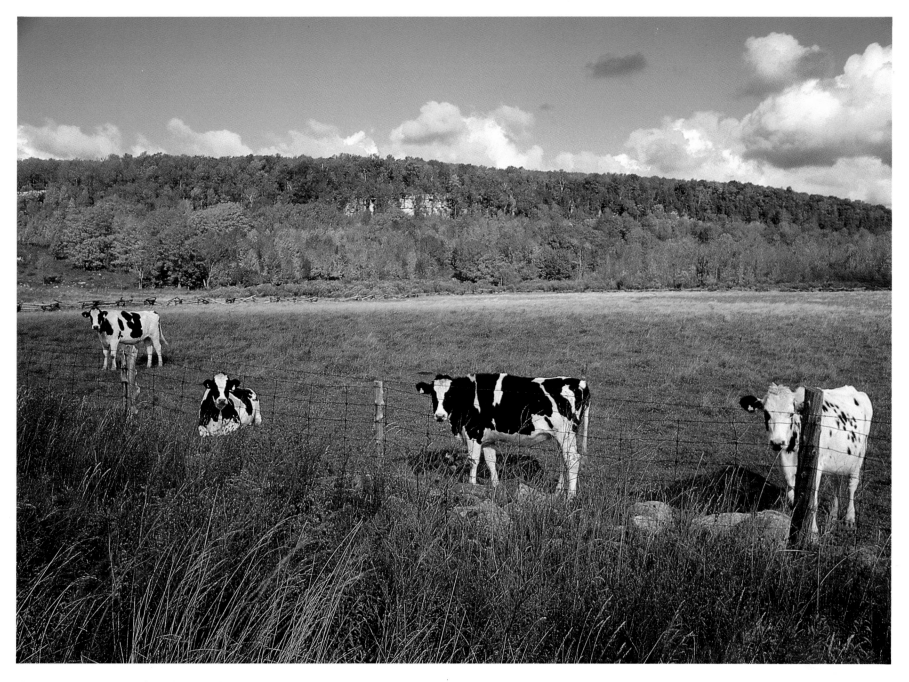

Farm country along the Niagara Escarpment.

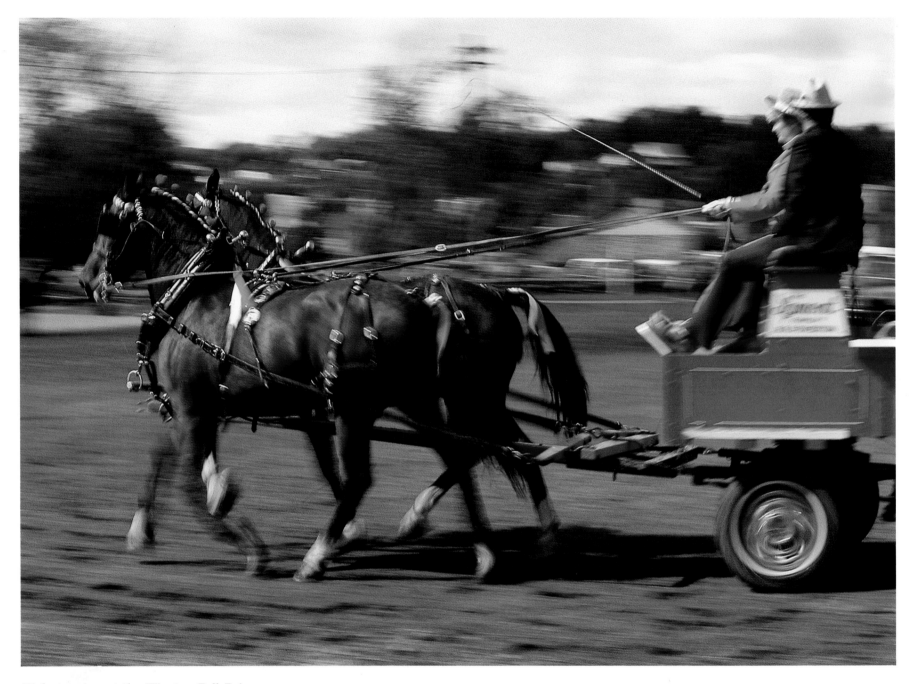

High-stepping at the Wiarton Fall Fair.

Chatting at the fair in Wiarton.

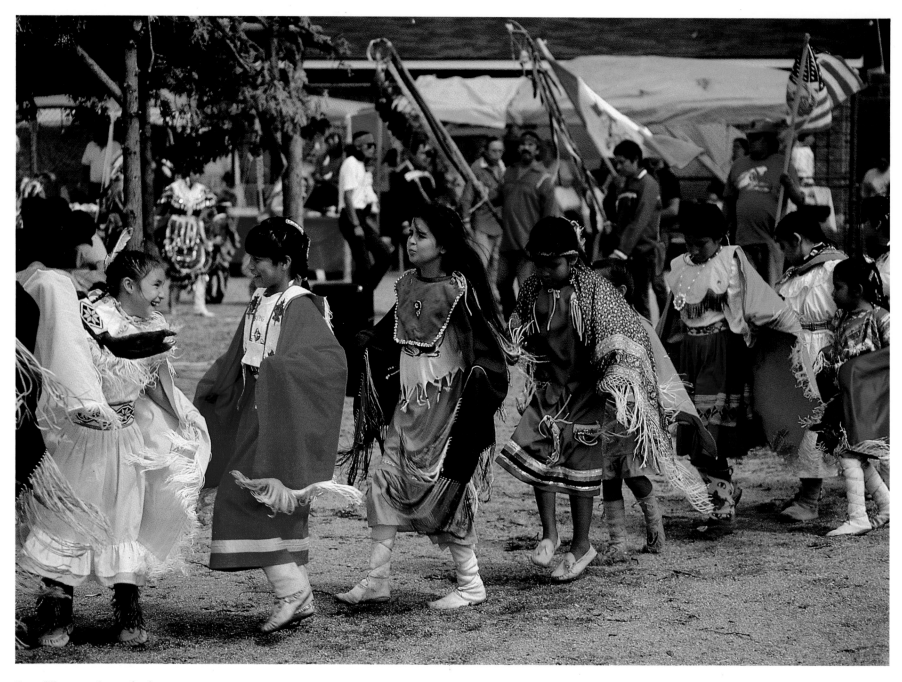

Pow Wow at Cape Croker.

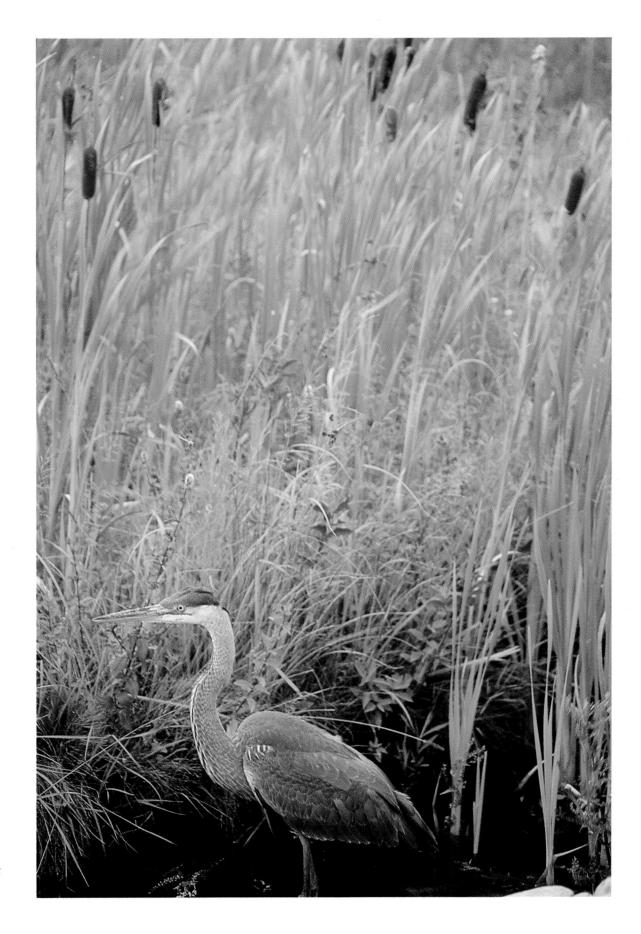

Great Blue Heron in the marsh at Cape Croker.

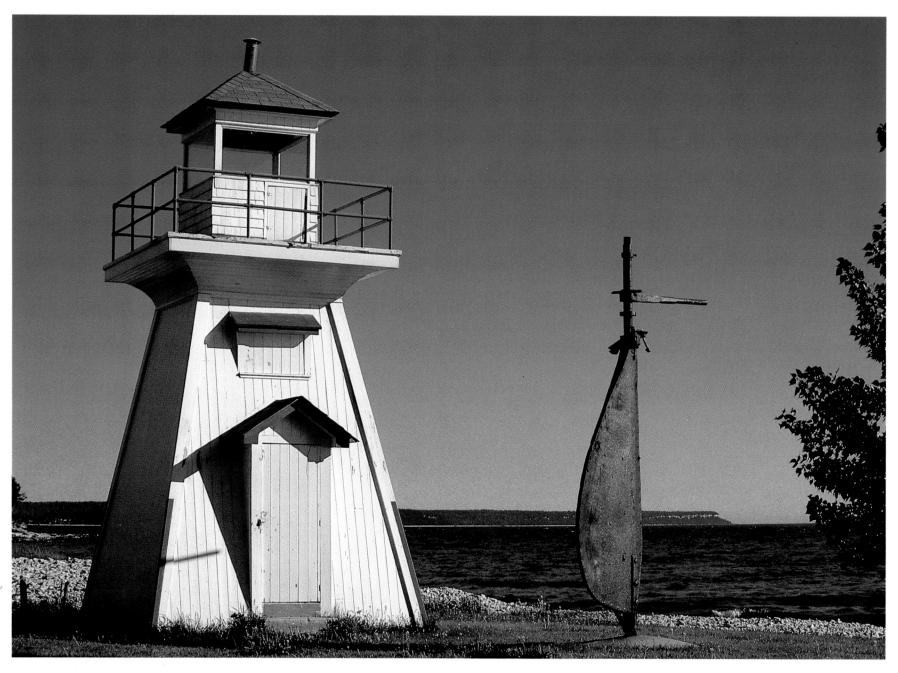

Lion's Head lighthouse.

THE LIGHTHOUSE AT CABOT HEAD

Not much happens at Cabot Head. It's a lonely headland at the dead end of a dirt road. To get to it you take the shoreline road from Dyers Bay and wind along beneath the Escarpment until you reach a windswept outpost. For almost 100 years there has been nothing out here except a lighthouse, built to guide ships through the treacherous waters around the Bruce Peninsula. The area is famous for sudden violent storms and dense fog. But on some summer days the waters look deceptively calm, like a blue blanket concealing the rusted wrecks that lie below.

The lighthouses strung along the Georgian Bay coast of the Bruce Peninsula were all built during the busy shipping years, between 1858 and 1903. They were erected on islands and other rocky outcroppings at Tobermory, Cove Island, Flowerpot Island, Lonely Island, Lion's Head, Cape Croker and Griffith Island. Some were circular stone towers called Imperial towers, others were four-sided tapered wooden structures with lean-to dwellings grafted to their sides and a separate lightkeeper's cottage. Back then, schooners bearing cargo and steamers loaded with passengers plied the Great Lakes in vast numbers, and the lighthouses were their lifelines. Many heroic tales are told of lightkeepers rescuing vessels from the hostile waters.

Ghost stories are told too. Many old-timers will swear there's a ghost at the Cove Island lighthouse, the last of the manned lights in the Parry Sound district. The story begins back in September 1881, when the *Regina*, a small schooner, sank just off the island and the body of Captain Amos Trip washed ashore. The lightkeeper buried the Captain somewhere on the island. And to this day his ghost still appears. Even in the dead of winter, he will pull up a chair at the table to play a hand of cards with the lightkeeper.

At Cabot Head the lighthouse is positioned high on the cliff. The original red iron lantern stood atop a 15-metre (48 ft) wooden tower. It could be seen for miles. Before the light was mechanized, the lightkeeper's job was demanding. The air pressure had to be pumped up for the foghorn, the wicks of the coal-oil lamp cleaned and trimmed, the oil tanks filled, and the glass kept polished. The rotation of the lights was done by a weight system, so the weights had to be cranked up during the night. For many years it was a two-man operation.

Two lightkeepers would bring their families out to this lonely promontory. It was too desolate for one man alone. There was no road at the time, so they either sailed out from Dyers Bay or came overland along the bush path from Gillies Lake. One family had living quarters in the base of the tower and the other lived in the cottage beside it.

Life at Cabot Head is different today. On a warm summer day the lighthouse keeper's wife is on the lawn doing cool-down stretches in her lycra tights. She's just back from her morning run. Behind her is what remains of the clapboard light tower, all painted in Canadian Coast Guard colours of red and white. It has been amputated below the light. Now, instead, there's a grey steel tower with an automated light that flashes every 10 seconds and which can be seen for 26 kilometres (16 mi). As the light flashes on and off like a disco strobe the young woman goes into the cottage to get an old framed photograph. It shows the Cabot Head lighthouse before the iron lantern was lopped off. "Isn't it a shame," she says sadly. Her husband was the youngest lightkeeper in the Parry Sound district and had spent ten years at Cabot Head. When they automated the light in 1989 he was transferred to Prescott, Ontario's other Coast Guard district. "We're not needed here anymore, except as a safeguard against vandalism," the young woman continues. "But we come in the summer because it's still home. We're really not lighthouse keepers anymore. Now we're just lighthouse sitters."

Springtime at Dyers Bay.

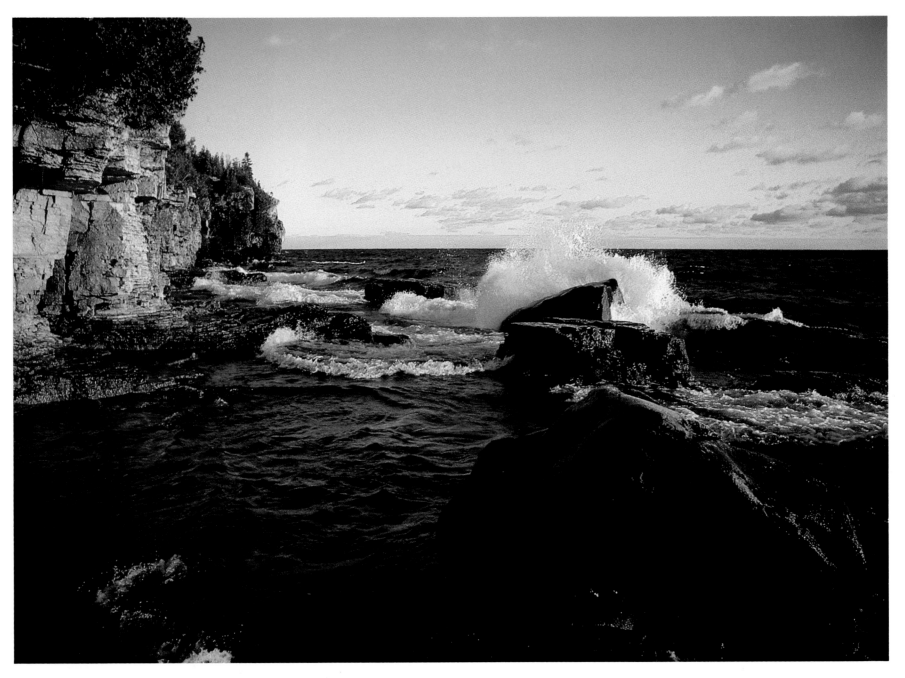

Wave-washed shoreline near the tip of the Bruce.

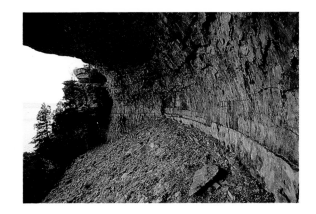

THE BRUCE

Springtime on the Bruce. The blue waters of Georgian Bay dance in the distance as the countryside comes to life after a long winter. Brilliant yellow clumps of lady's-slipper spread along the roadside and the fragrant scent of cedar perfumes the air. Dozens of orchid species bloom on this rugged peninsula. The 45th parallel passes through here, a latitude favoured by these delicate flowers, and because it's cradled by water on all sides, the peninsula has a maritime climate.

It's a unique piece of land, the Bruce Peninsula. It juts up between Lake Huron and Georgian Bay like a finger pointing north. If it extended a little further it would connect with Manitoulin Island, and Georgian Bay would become the sixth Great Lake instead of a large bay.

Some 805 kilometres (500 mi) of shoreline rim the Peninsula. On the eastern shore, the waters of Georgian Bay pound the cobbled beaches, ancient cedar forests grow on the headlands, and the limestone cliffs of the Niagara Escarpment plunge into the bay. The western shore is much gentler. It has sprawling white sand beaches, rolling pastures and sheltered inlets where people gather to watch the sunsets on Lake Huron.

One long, lonely highway travels up the spine of the Peninsula from Wiarton to Tobermory. The surrounding countryside is littered with abandoned farms. Overgrown lilacs bloom in the rubble of deserted homesteads, and weathered tombstones stand in forgotten graveyards. It looks as if the land has resisted settlement and reverted to its pre-pioneer landscape.

Plots of farmland were first sold to settlers in this area in 1856, just a year after the railroad reached Collingwood. Following the railroad, steamer service was put in place along the shore from Collingwood to Owen Sound, which opened the south-western shore of Georgian Bay for settlement. The Indians who first settled the Bruce had already given it up. It wasn't long before a stream of eager pioneers began lining up for land holdings. But the dreams of successful homesteading soon turned sour. Most of the newcomers bought their property at highly inflated prices during a brief land boom, planning to pay off their mortgages by working their holdings. However, the timber rights to their properties had been sold separately and the settlers were only able to take down enough trees to build their homes. Without the ability to sell the timber or clear the land for farming, they were caught in a hopeless situation. Furthermore, when the lumbermen finally got around to cutting down their trees, a horrible reality presented itself. The limestone land was sprinkled with thin soil and gravel, totally unsuitable for productive farming. Most of the homesteaders left, heading up the shore to Parry Sound or on to the more fertile western prairies, where there was promise of a better future.

Today the Bruce Peninsula is still sparsely settled. A few farms exist, but tourism keeps the area alive. Its unique landscape prompted the Canadian government in 1987 to convert a 140-square-kilometre (54 sq mi) section into the Bruce Peninsula National Park. And in 1990 an arm of the United Nations designated the Niagara Escarpment as a global biosphere reserve. The section of escarpment that runs along the Bruce Peninsula will be the core protected area. This means that the Bruce Peninsula will forever be preserved, like other environmentally important parts of the world, areas such as Ecuador's Galapagos Islands, the Serengeti National Park in Tanzania, and the Florida Everglades. The settlers' losses in the Bruce Peninsula have ended up being the world's gain.

Overhanging Point in Bruce Peninsula National Park.

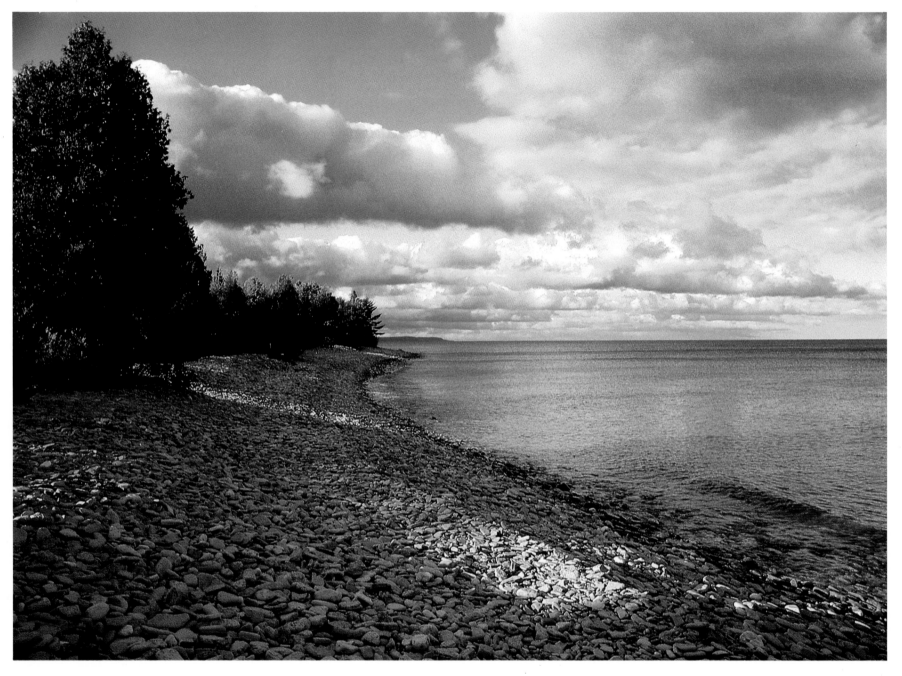

A pebble beach at Cape Chin.

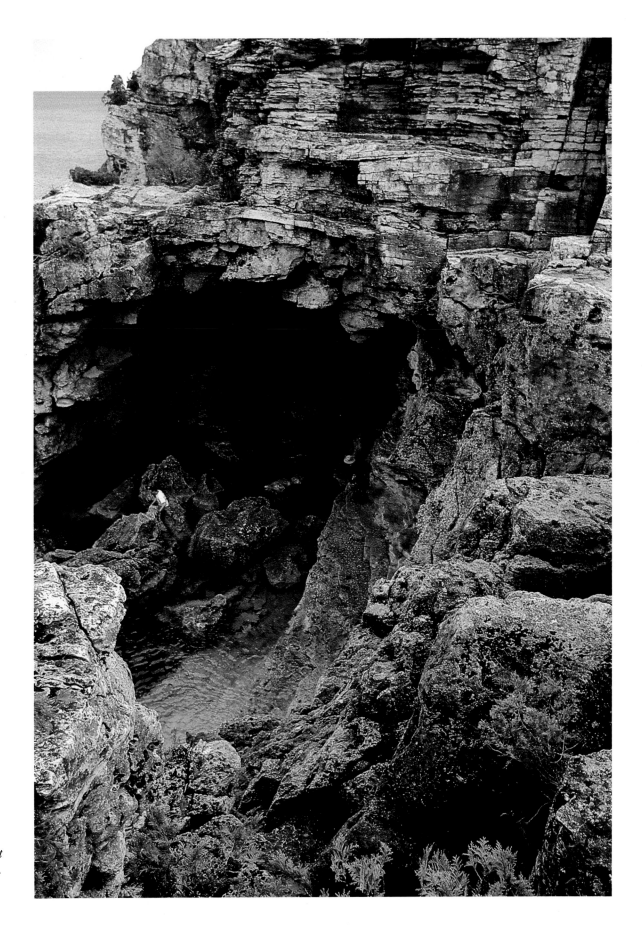

*The limestone escarpment
in Bruce Peninsula National Park.*

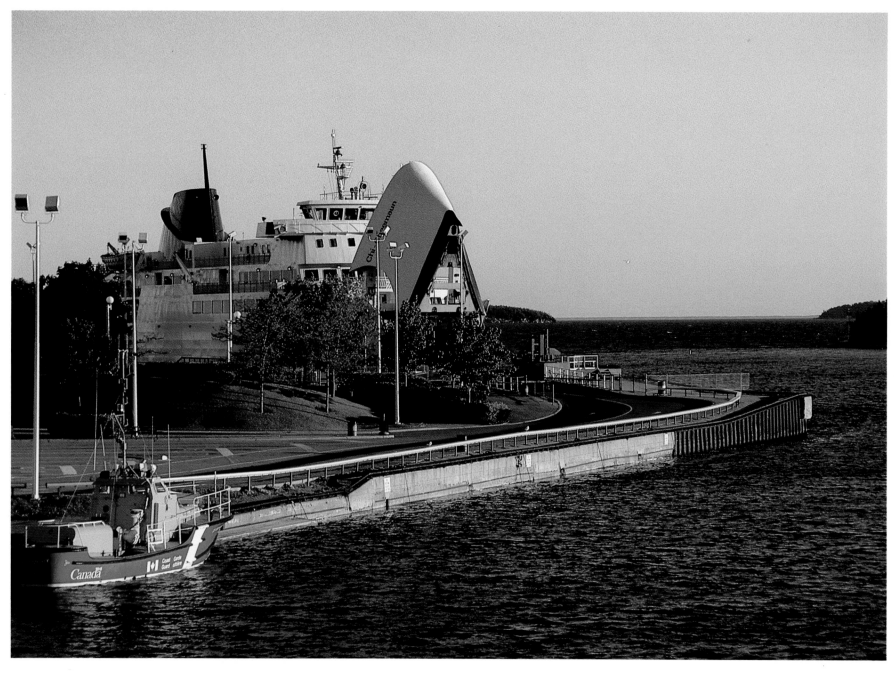

The Chi-Cheemaun *ferry in Tobermory loading for the trip to Manitoulin Island.*

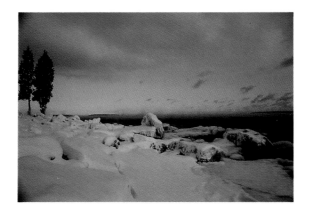

TWO TUB TOWN

It's midsummer in Tobermory. A gentle breeze fans away the heat and clouds that drift overhead like wisps of shredded cotton. Like other land's-end towns, there's a quirkiness about this place, with its two harbours named Little Tub and Big Tub, its red-and-white lighthouse, and its dizzying array of dockfront shops selling T-shirts, homemade fudge and fishing lures. A stream of glass-bottom boats chug in and out of the harbour loaded with tourists heading out to view the underwater shipwrecks that have made the town famous.

The long hiking trail known as the Bruce Trail ends here, and fresh-faced backpackers trek in to swell the town's population. You see them, hunched beneath their knapsacks, wandering the jetties lined with fishing tugs and luxury yachts. Scuba divers congregate here too. Lean and black-suited, they head offshore in crowded rubber dinghies. The rest of the summer crowd, except for a few hundred townsfolk, are tourists and fishermen. From here, at the very tip of the Bruce Peninsula, people head for Manitoulin Island on the *Chi-Cheemaun* or the *Nindawayma*, the two enormous ferries with hulls that open like whale jaws to let on hundreds of cars. In Ojibwa their names mean "Big Canoe" and "Little Sister."

The land does end at Tobermory. The abrupt blunt edge of the Niagara Escarpment dives underwater here, rising in occasional jagged shoals or desolate islands. Finally the ridge of limestone rock rears up out of the water to form Manitoulin Island. In the 48 kilometres (30 mi) between Tobermory and Manitoulin Island, the waters are littered with shipwrecks. Only three channels permit ships to cross this dangerous stretch of water where large shoal masses rise unexpectedly from the deep to lurk within a few metres of the surface. This is shipwreck country.

Many of the wrecks date back to the 1850s, when ship traffic around Tobermory consisted of tall-masted schooners from the lower lakes. They sailed up with supplies for the developing lumber towns around Georgian Bay. On their return they were loaded with squared timbers, building materials for the American cities like Chicago that were growing up along the shores of the lower lakes. Frequent storms lash this jagged tip of land, and when a ship ran aground or capsized, there was no one to come to the rescue.

It wasn't until 1871 that Tobermory's first settler arrived, a Scot named John Charles Earl. He built a cabin at Big Tub, the harbour that stretches inland like a thin Norwegian fjord. Because the harbour was frequently used as a refuge by vessels seeking shelter from storms, Earl fastened a lantern on top of a tree to help guide them in. In return the ships' captains gave him bountiful supplies from their cargo. And later, when the Big Tub Lighthouse was built in 1885, John Charles Earl was appointed its first keeper.

The town thrived for a while as a logging and fishing village, but long after those industries collapsed it was the ill winds that turned into good fortune for Tobermory. The clarity of the waters that surround the two harbours have made this the best wreck-hunting location on the Great Lakes. Every summer, divers gather here to submerge themselves in the cold, clear Bay and examine the watery graves, hoping to add to the list of sunken discoveries.

The remains of 21 known sail and steam vessels lie beneath the water in the area called the Fathom Five National Marine Park, established by the Ontario government in 1975. The park is Canada's first underwater park. It encompasses 130 square

Tobermory in January.

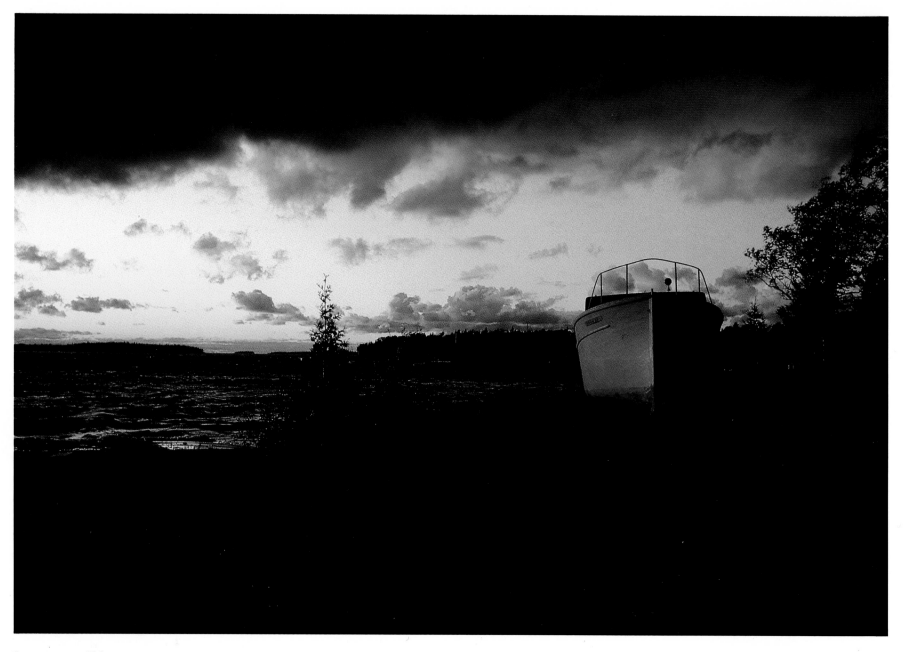

Sunset near Tobermory.

kilometres (50 sq mi) of Lake Huron and Georgian Bay and includes 19 islands. The most famous of these is Flowerpot Island, named for the two rock pillars shaped like flowerpots.

Sculptured by wave and ice erosion, these "flowerpots" stand like sentinels on the east side of the island.

The breeze is dying down as the group files onto the *Blue Heron V*, a double-decker glass-bottom boat tied up in Little Tub Harbour. As the boat slips its moorings the captain exclaims that it is "a fine day for underwater viewing," and before long the boat is circling slowly at the head of Big Tub Harbour.

There, beneath the glass, is the *Sweepstakes*, a 120-foot-long two-masted schooner. In August 1885 she was sailing with a full cargo of coal destined for Parry Sound when she ran aground at Cove Island. No lives were lost and she was almost saved by a tug that towed her into the harbour, but just 15 metres (50 ft) from the dock she sank. She lies there today in 6 metres (20 ft) of water with her hull nearly intact, a ghostly tribute to the skills of the shipbuilders who built them to last and to the hard lives of the crew who were betrayed by the treacherous waters of Georgian Bay.

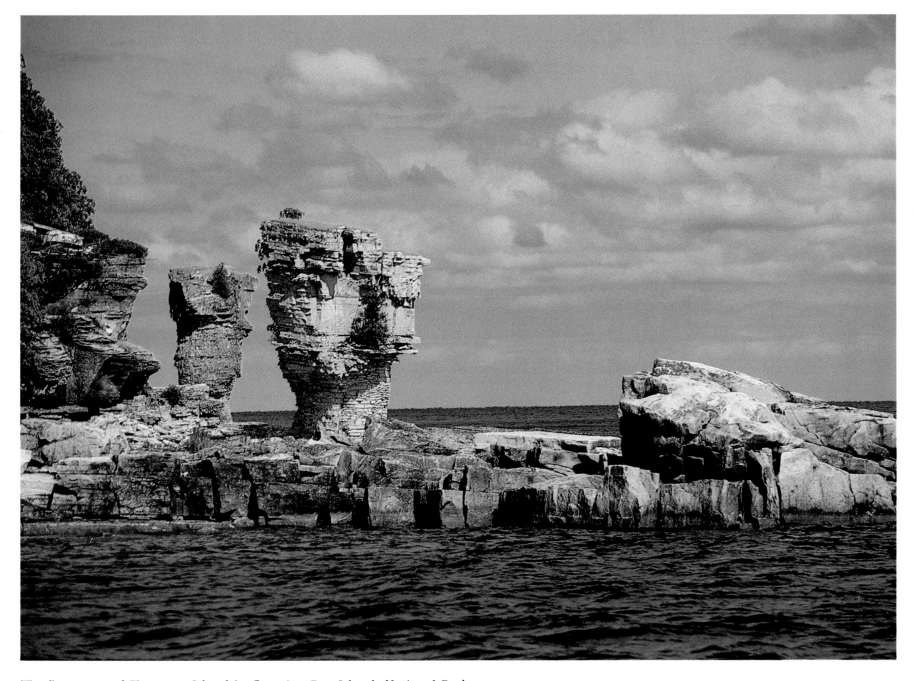

The flowerpots of Flowerpot Island in Georgian Bay Islands National Park.

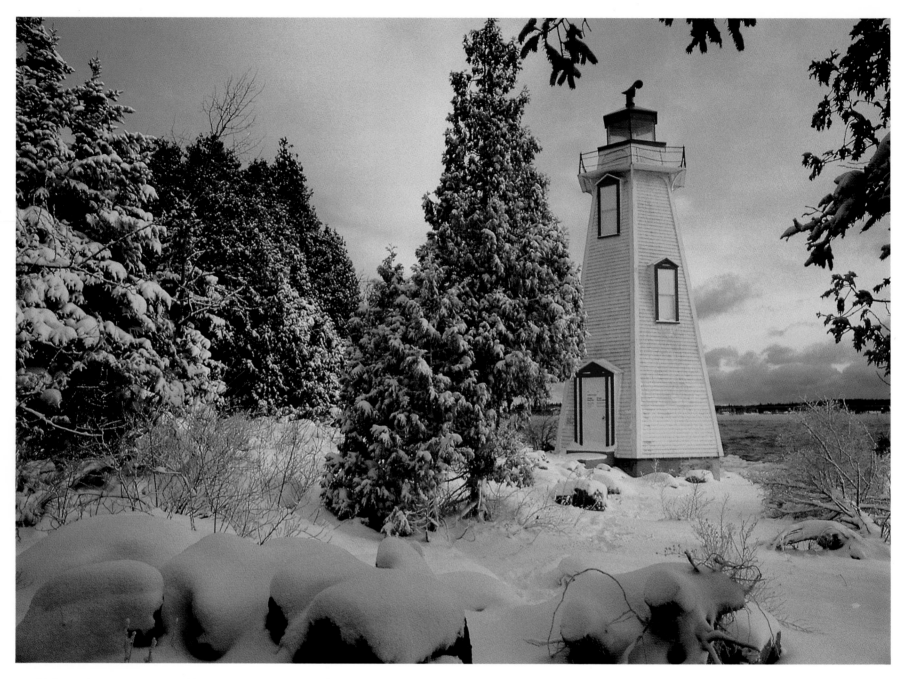

Big Tub Harbour lighthouse, Tobermory.